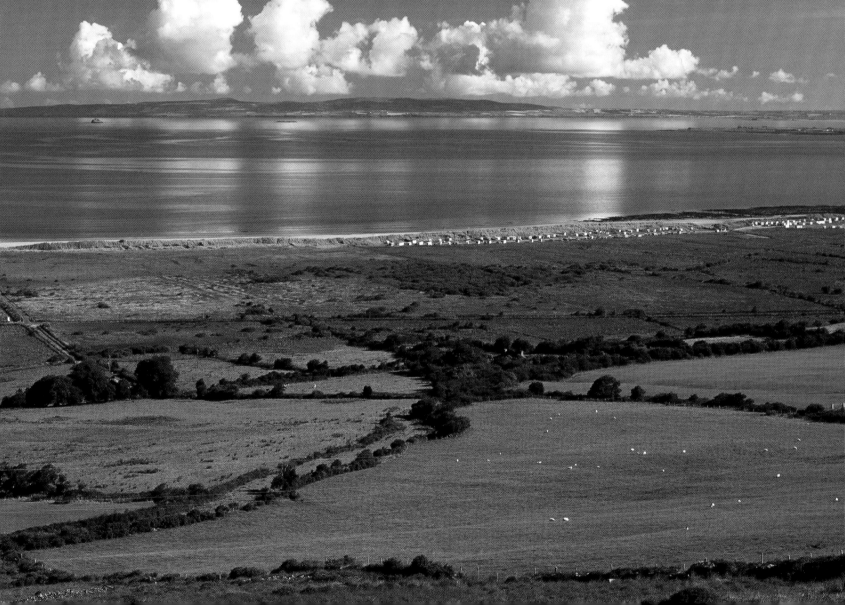

THIS IS
KERRY

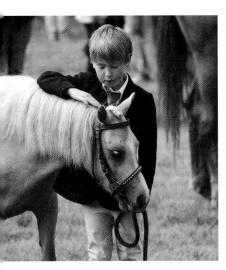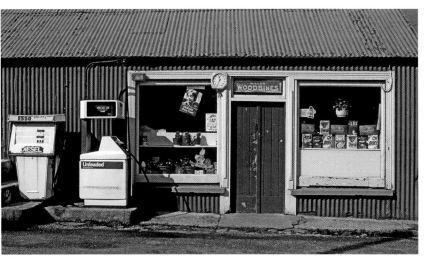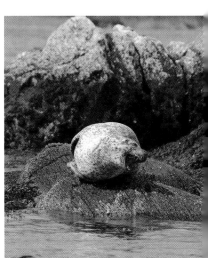

THIS IS
KERRY

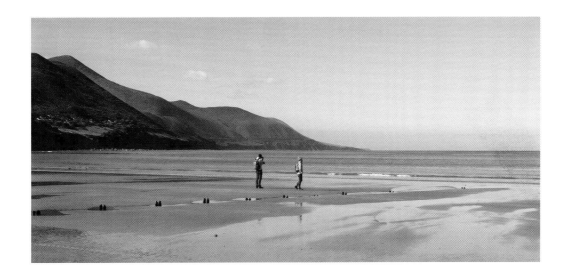

MICHAEL DIGGIN

The Collins Press

FIRST PUBLISHED IN 2015 BY
The Collins Press
West Link Park
Doughcloyne
Wilton
Cork

© Michael Diggin 2015

A CIP record for this book is available from the British Library.

Cased ISBN: 978-1-84889-240-8

Design and typesetting by Bright Idea, Killarney
Typeset in Goudy Old Style and Trajan Pro
Printed in Malta by Gutenberg Press Ltd

INTRODUCTION

Kerry is a county apart: the farthest outpost of western Europe, its unique combination of craggy mountains, tranquil lakes, vibrant towns and rugged coastline makes for a photographer's paradise. Tralee-born Michael Diggin has traversed the length and breadth of his native County Kerry to capture on camera the diversity of landscape, weather, scenery and people. Its peninsular form and mountainous nature further provide many vantage points from which to view this remarkable landscape of contrasting beauty.

This is Kerry takes you on a mesmerising tour of the county. In a series of atmospheric images, Michael Diggin encapsulates all that is special about Kerry and clearly shows why it is Ireland's premier visitor destination. Using the dramatic landscape as a backdrop, he captures the spirit and colour of all that is best in Kerry. In addition to scenery, flora and fauna, buildings and towns, the warmth and relaxed lifestyle of Kerry comes alive in this collection.

With more than 150 stunning photographs, Michael Diggin has created a timeless tribute to the beauty and character of the kingdom of Kerry. Join him on a tour of an extended Ring of Kerry.

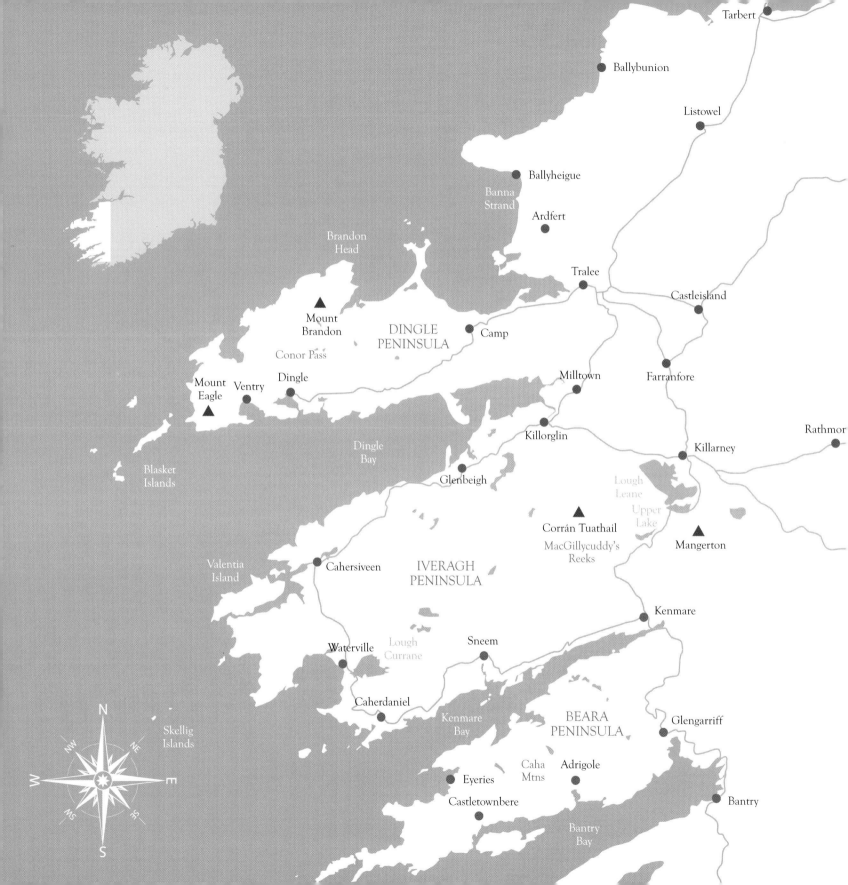

Tarbert

Ballybunion

Listowel

Ballyheigue

Banna
Strand

Ardfert

Tralee

Castleisland

Brandon
Head

▲
Mount
Brandon

DINGLE
PENINSULA

Camp

Conor Pass

Milltown

Farranfore

Mount
Eagle

Ventry

Dingle

▲

Killorglin

Killarney

Rathmor

Dingle
Bay

Glenbeigh

Lough
Leane

Upper
Lake

Blasket
Islands

Corrán Tuathail

▲

MacGillycuddy's
Reeks

Mangerton

▲

Valentia
Island

Cahersiveen

IVERAGH
PENINSULA

Kenmare

Waterville

Lough
Currane

Sneem

Skellig
Islands

Caherdaniel

Kenmare
Bay

BEARA
PENINSULA

Glengarriff

N

NW

NE

Caha
Mtns

Adrigole

W

E

Eyeries

SW

SE

Castletownbere

S

Bantry

Bantry
Bay

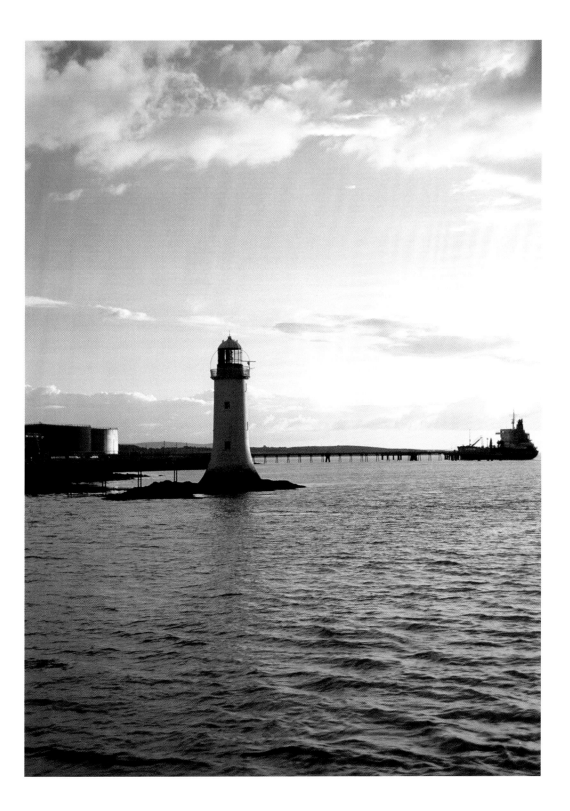

Tarbert Lighthouse
and the ESB oil jetty
on the River Shannon
silhouetted against
the evening sky.

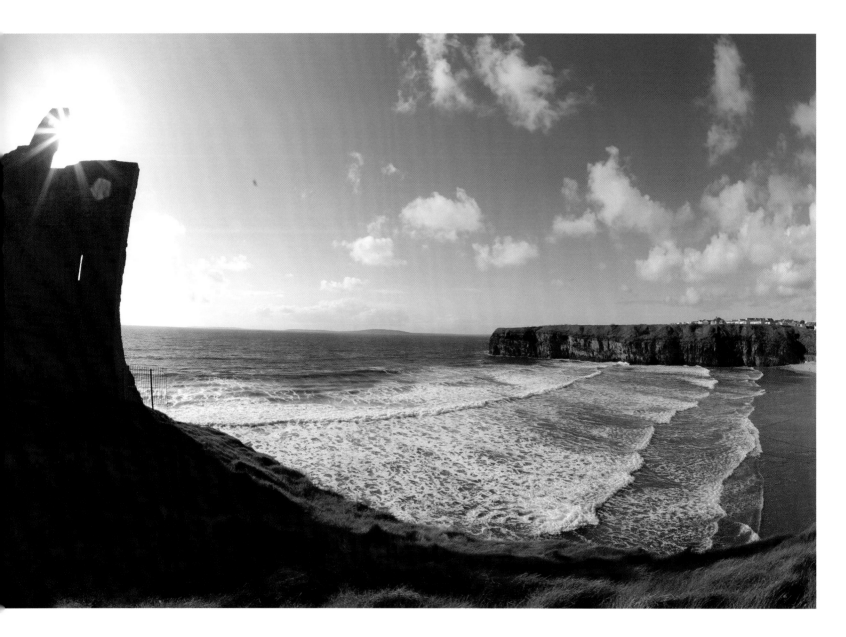

The ruins of sixteenth-century Ballybunion Castle overlooking Ballybunion Beach.

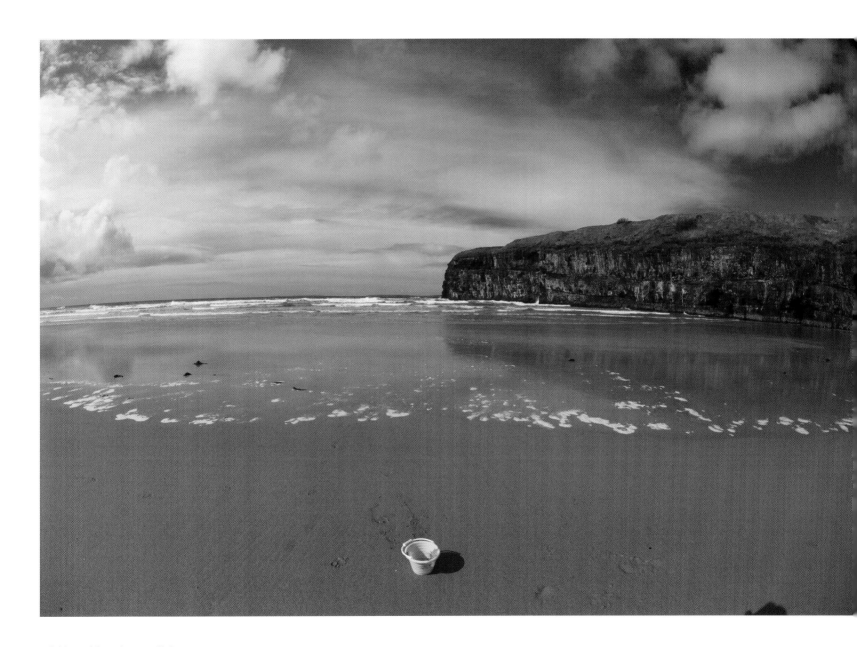

Cliffs and beach at Ballybunion.

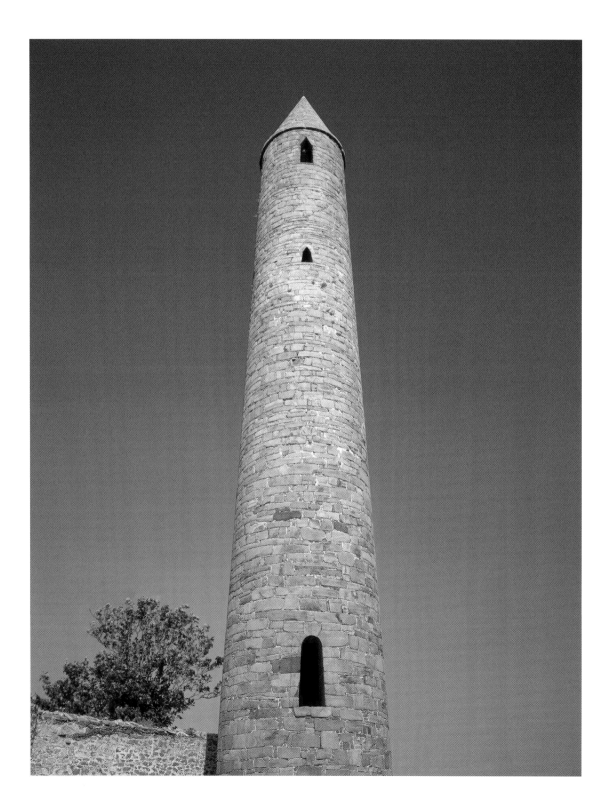

Rattoo Round Tower near Ballyduff, one of the most elegant and well preserved in the country, is the only complete one in Kerry.

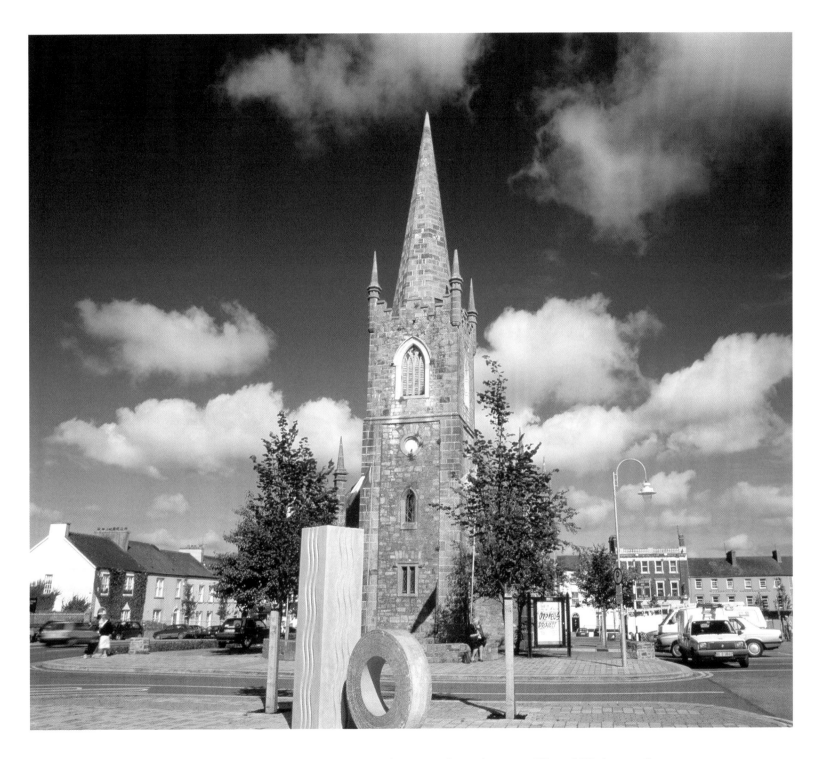

Listowel is one of the principal towns in north Kerry, with a strong literary tradition, hosting a Writers' Week annually.

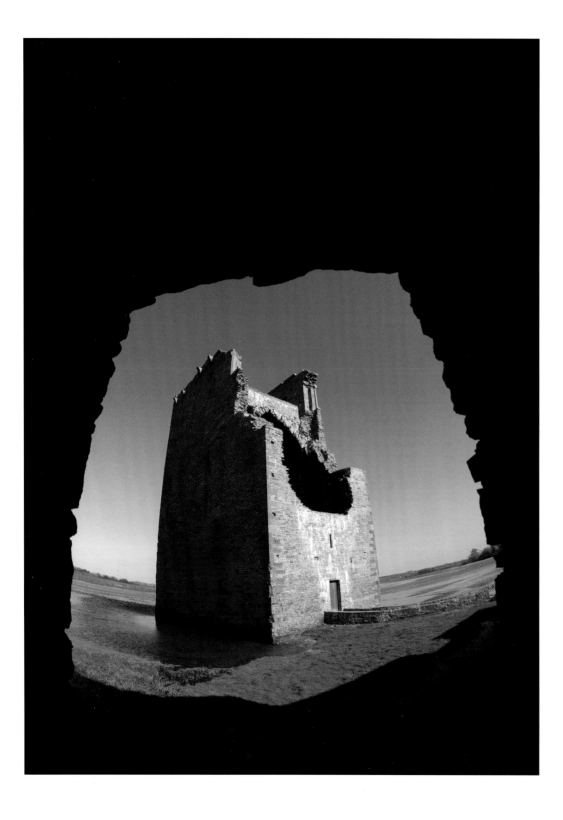

Carrigafoyle Castle
near Ballylongford
is a fine example of a
fifteenth-century tower
house. In 1649 the
castle was destroyed
by Cromwellian forces.

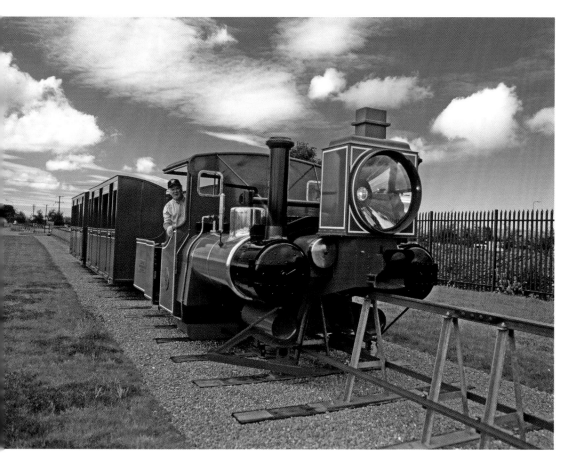

The Lartigue monorail.
This replica monorail is a
recreation of the original built
by the French engineer Lartigue,
which ran from Listowel
to Ballybunion.

The Abbeydorney Ploughing
Match is an annual event which
attracts old steam-engines.

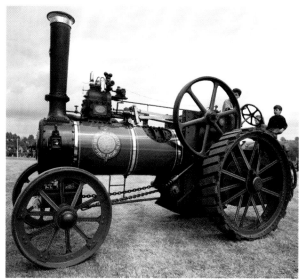

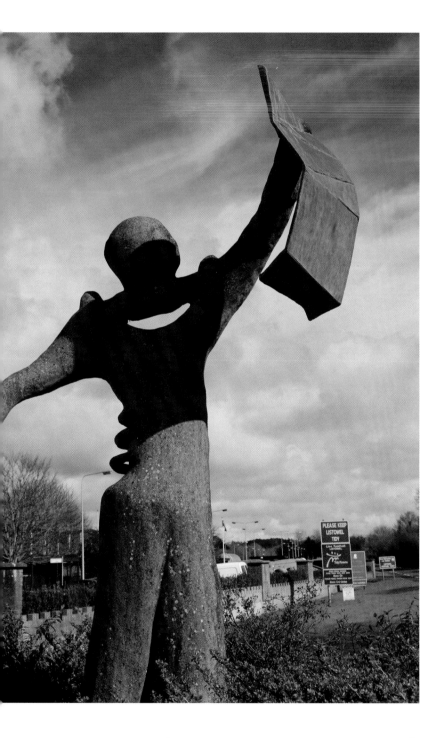

A sculpture of one of Listowel's most renowned sons, the playwright and novelist John B. Keane. ➤

Listowel Writers' Week is celebrated with this sculpture of a literary figure.

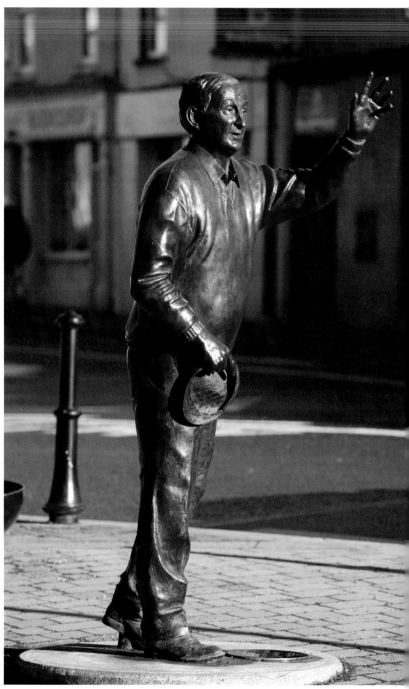

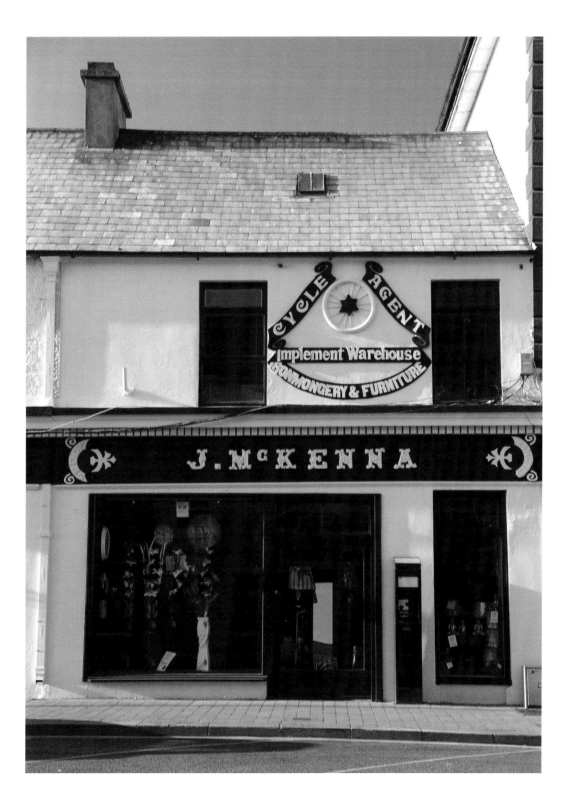

A traditional shop front in Listowel.

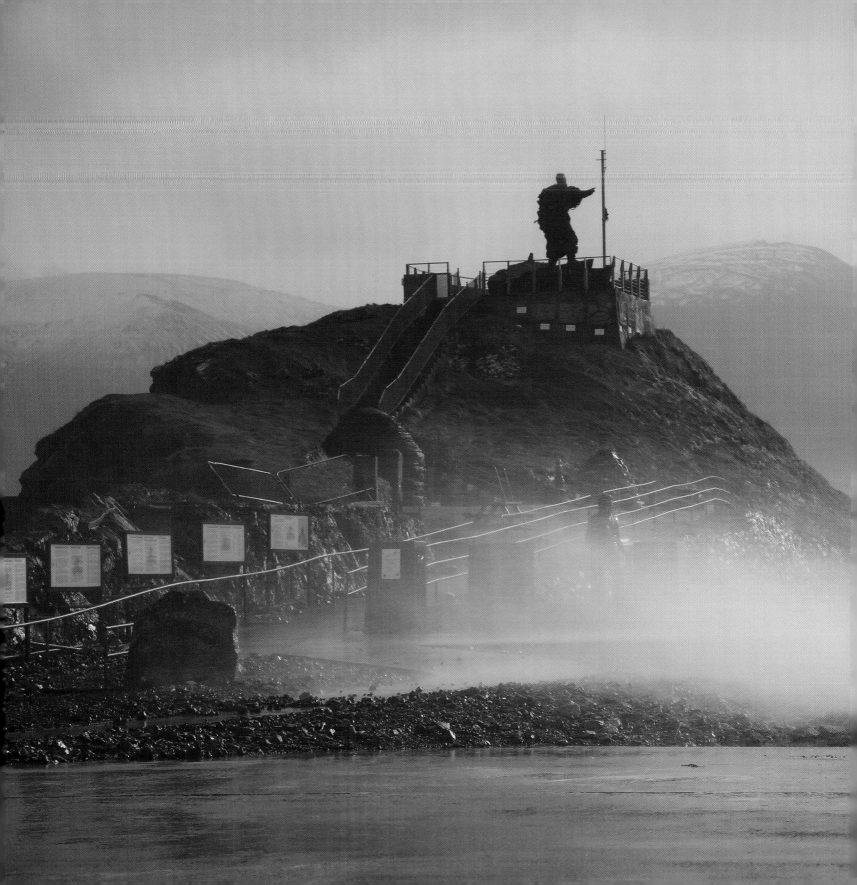

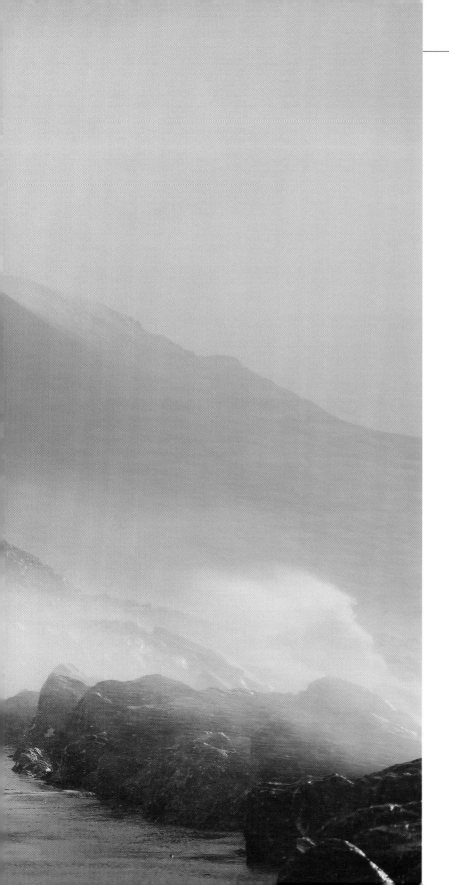

The statue of St Brendan the Navigator in Fenit.

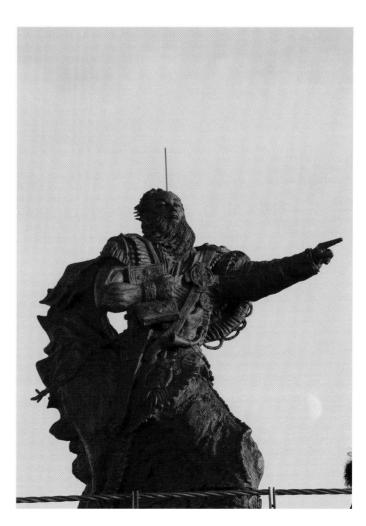

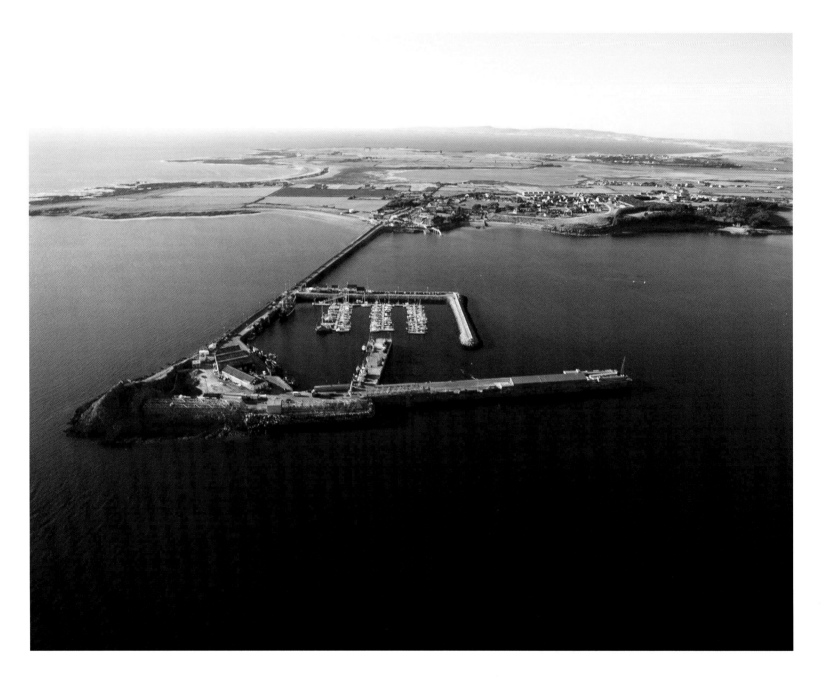

Fenit Harbour on Tralee Bay. The Liebherr Crane factory exports through this port. It is also the base for the local yacht club.

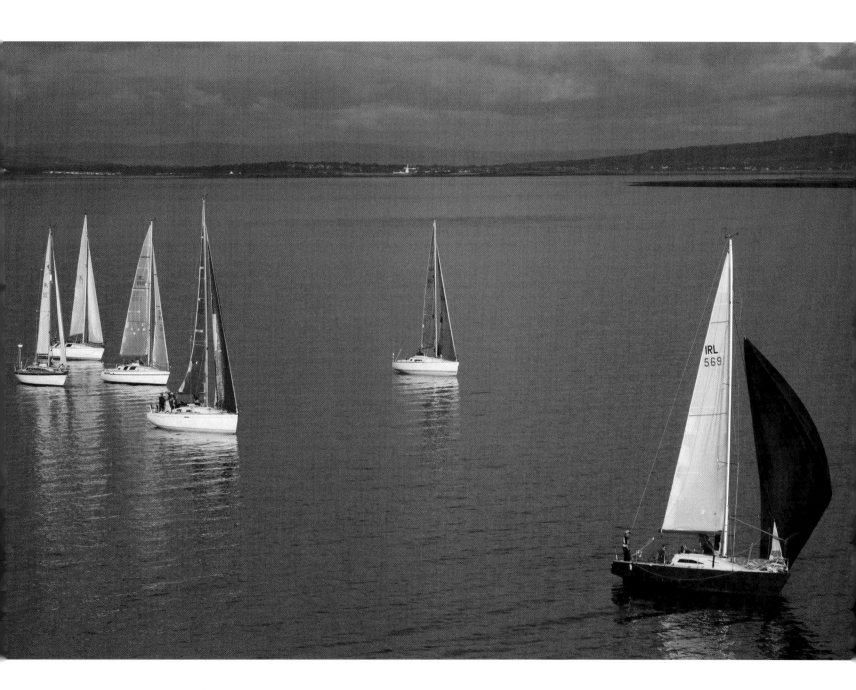

Lining up for the starting pistol at Fenit.

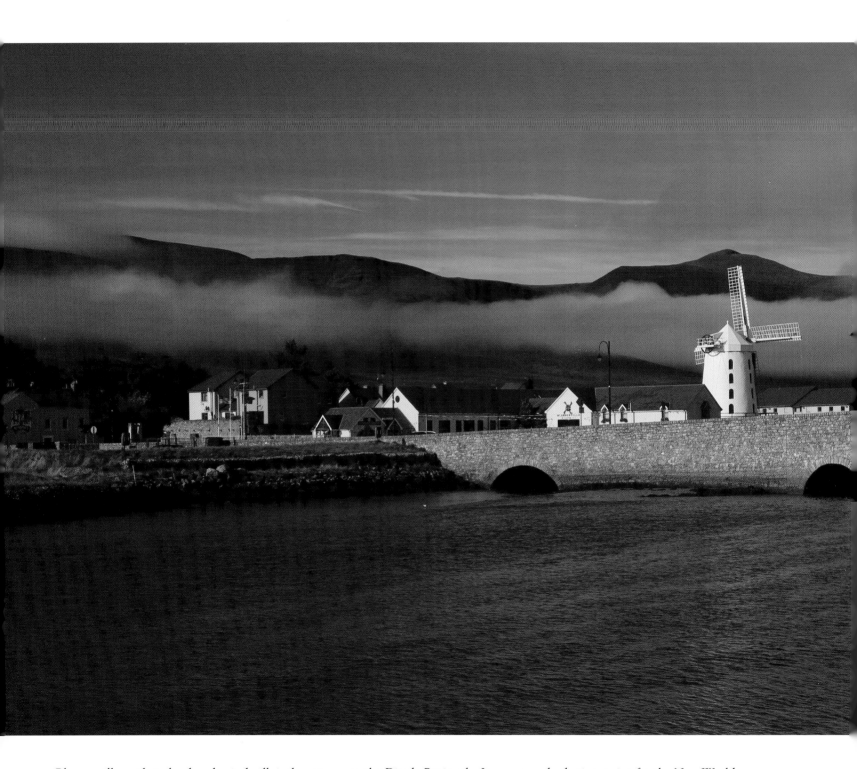

Blennerville, with its landmark windmill, is the gateway to the Dingle Peninsula. It was an embarkation point for the New World.

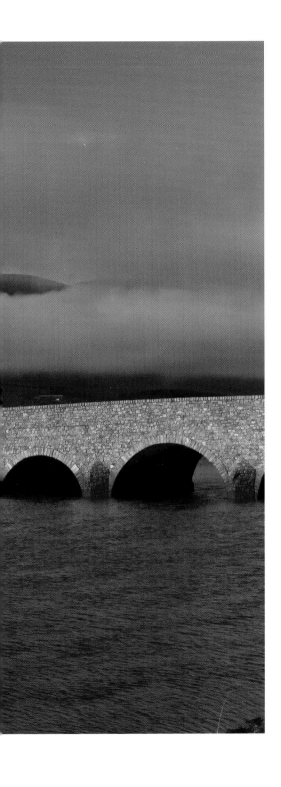

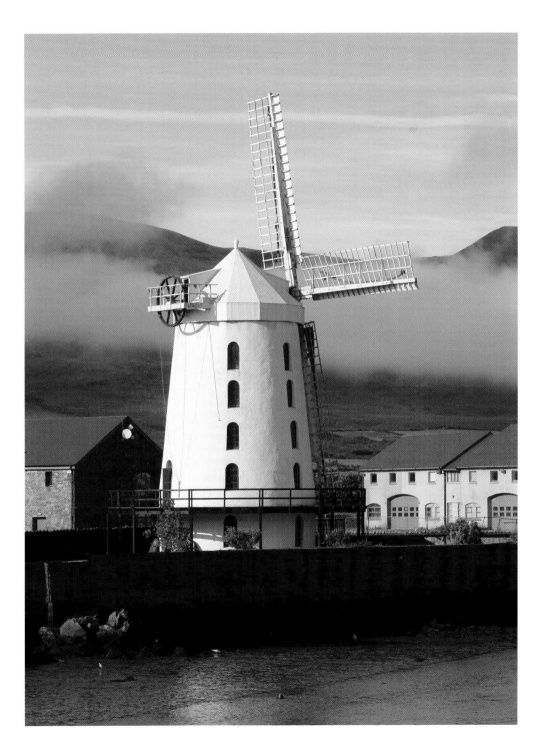

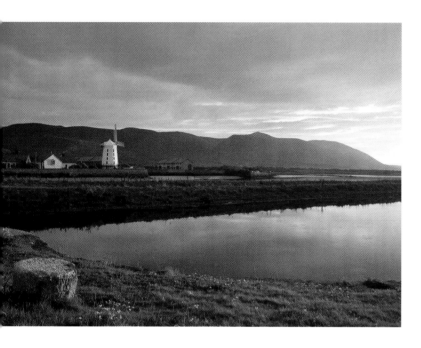

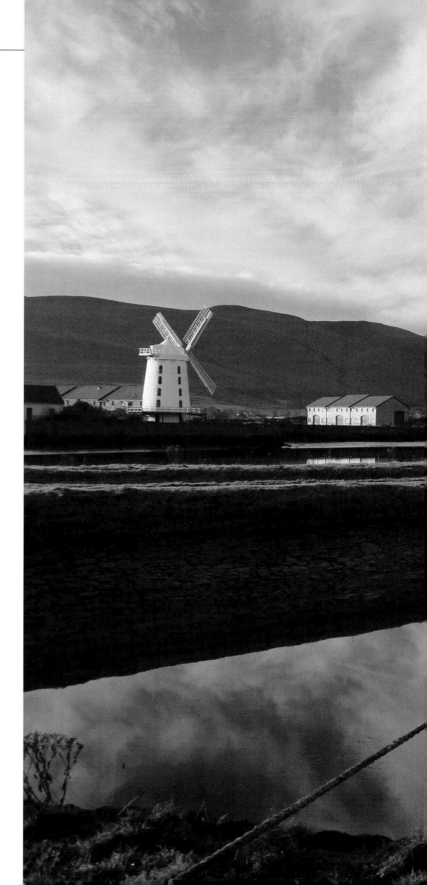

⬆ Sunset over Blennerville.

➡ A narrowboat at Blennerville.

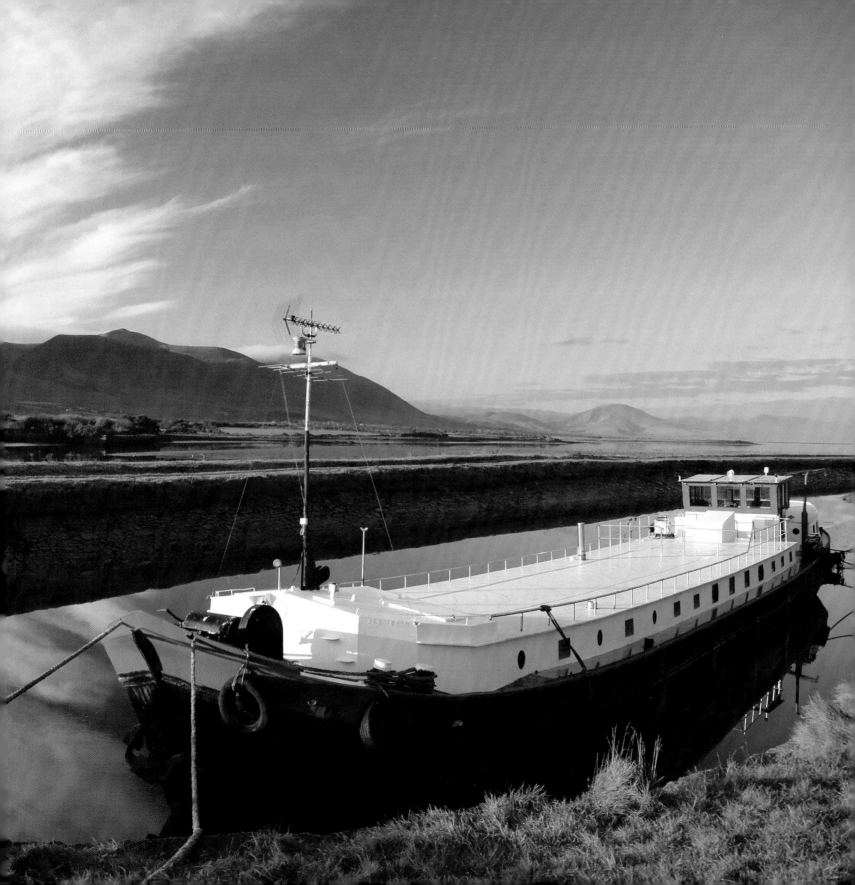

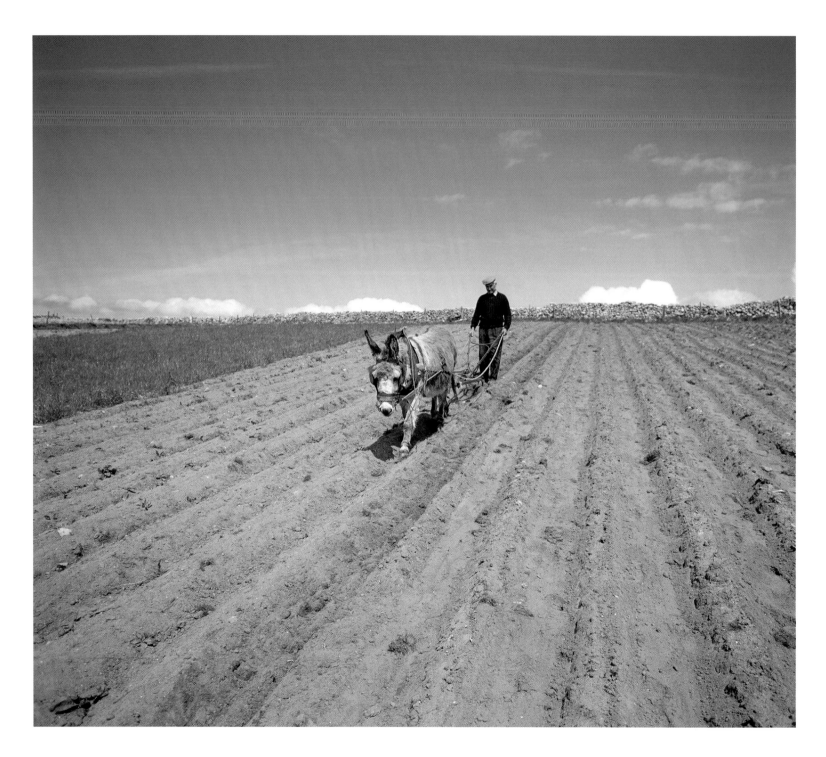

An elderly farmer tending his potato crop.

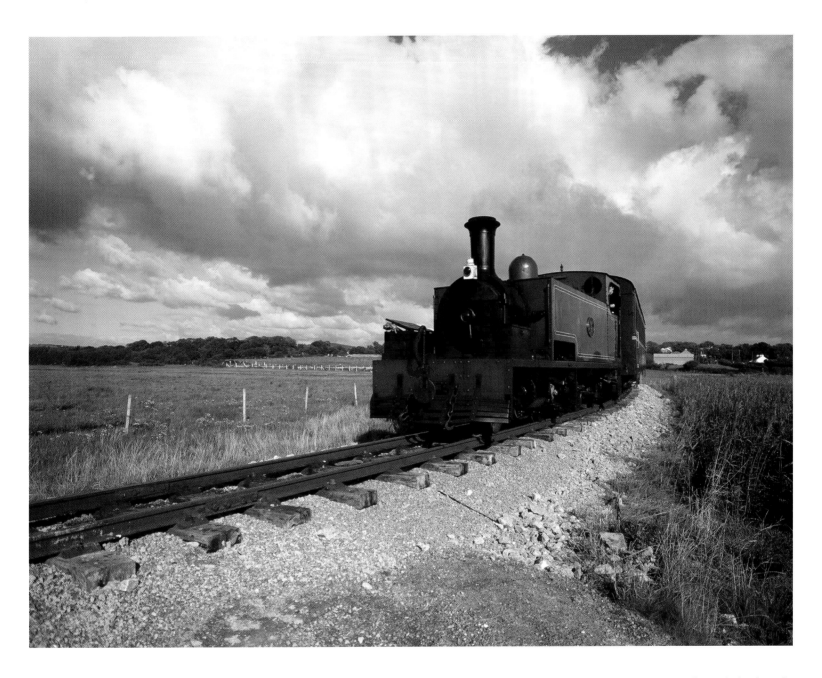

When the Tralee-to-Dingle Steam Railway closed in 1939, the steam engine was exported to America. After many years it was brought back and new tracks and facilities reconstructed to re-enact the train journey on the 3km stretch from Ballyard in Tralee to Blennerville. Since 2006, there have been no operations on the line but local interest groups hope it can be revived.

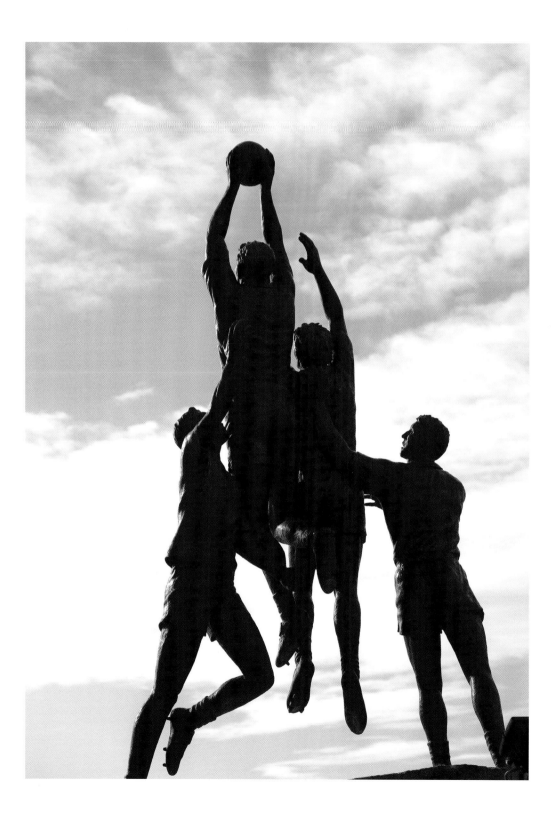

Kerry footballers have won more All-Ireland football championships than any other county and are celebrated in a sculpture on the main road into Kerry's capital town, Tralee.

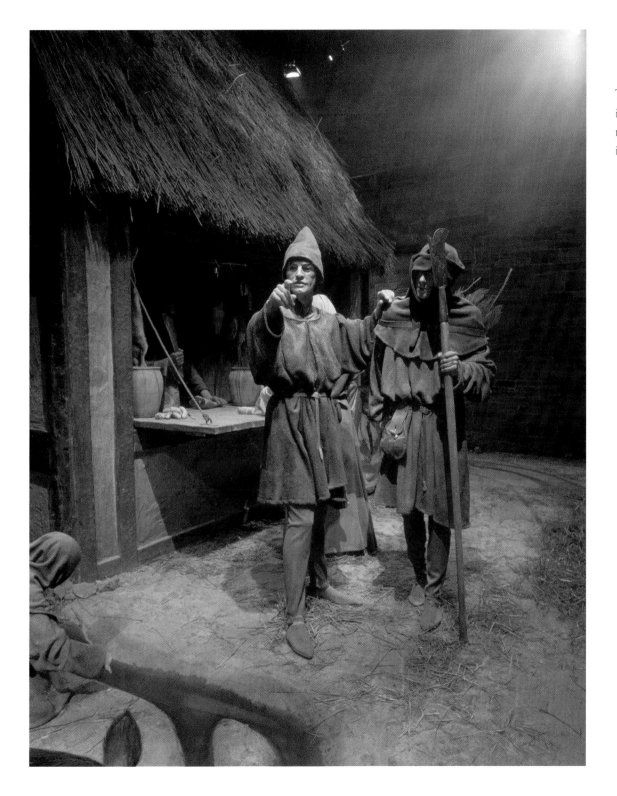

The Geraldine Experience
in Tralee recreates a
medieval market day
in the town.

Tralee Golf Course (eighteen holes) is situated at Barrow, facing the wild Atlantic.

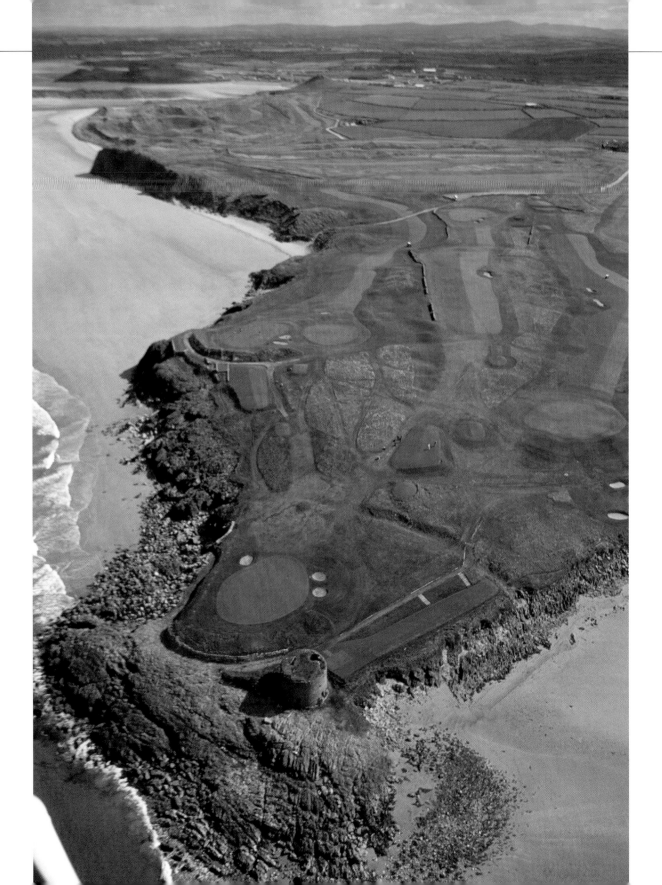

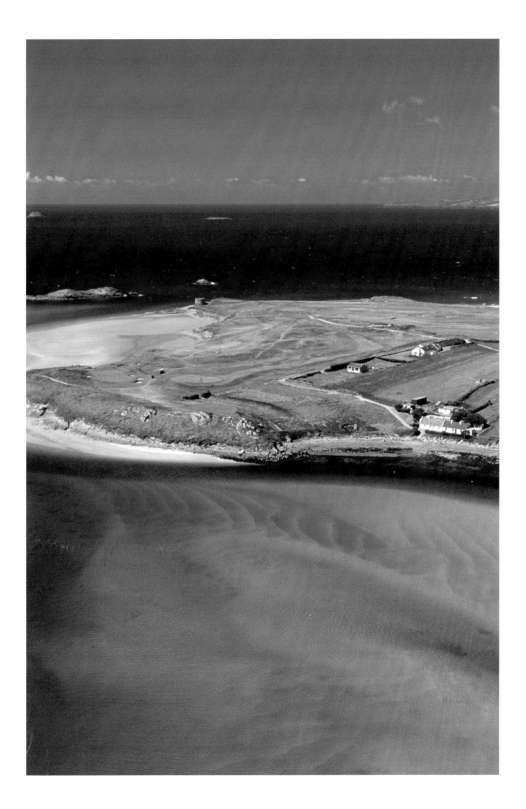

An aerial view of
Barrow Harbour
on Tralee Bay.
It was once used
to import wine
and sherry from
Spain and the
Low Countries.

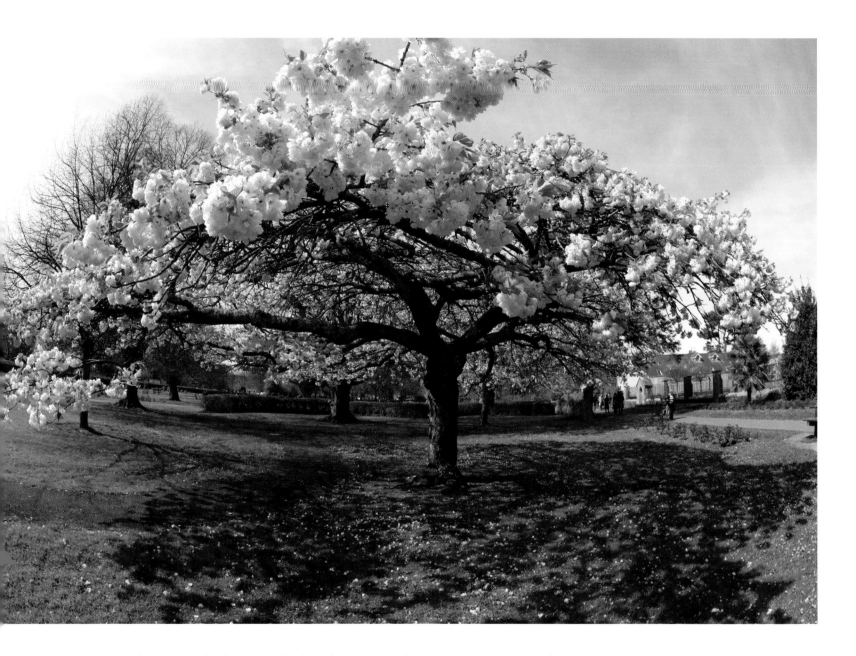

Tralee town park was set up by the Denny family and is home to a large variety of foreign shrubs, trees and herbs from around the world, including this Japanese cherry tree.

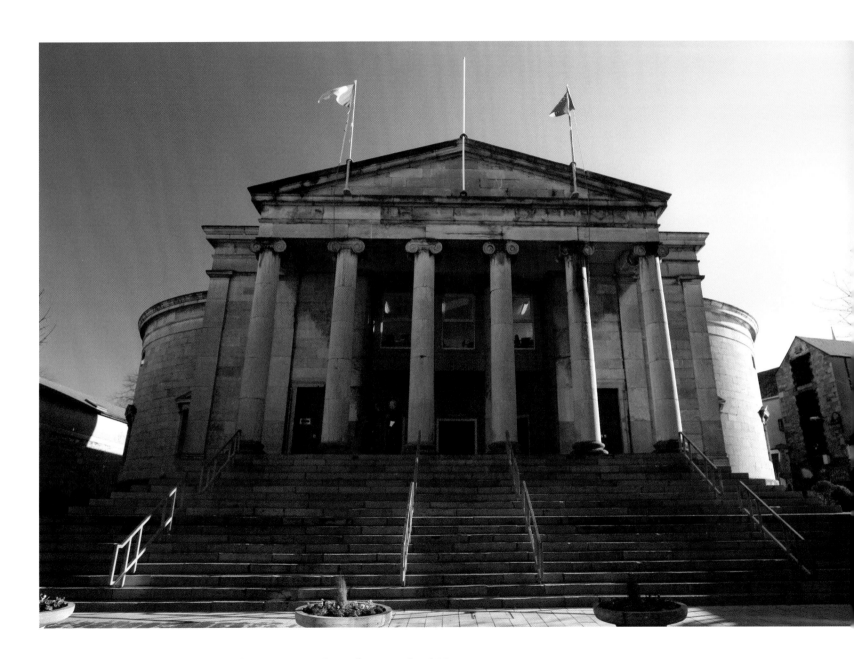

Tralee's limestone courthouse was built in 1835 to a design by Sir Richard Morrison.

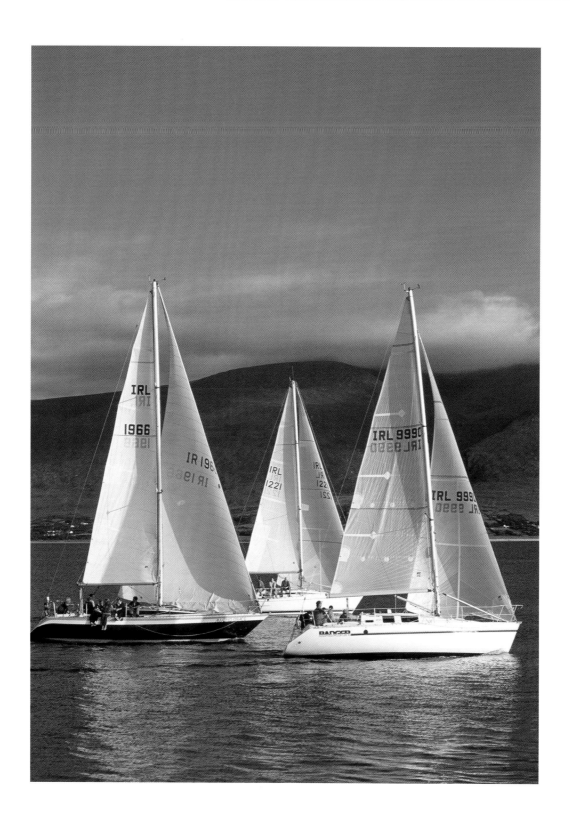

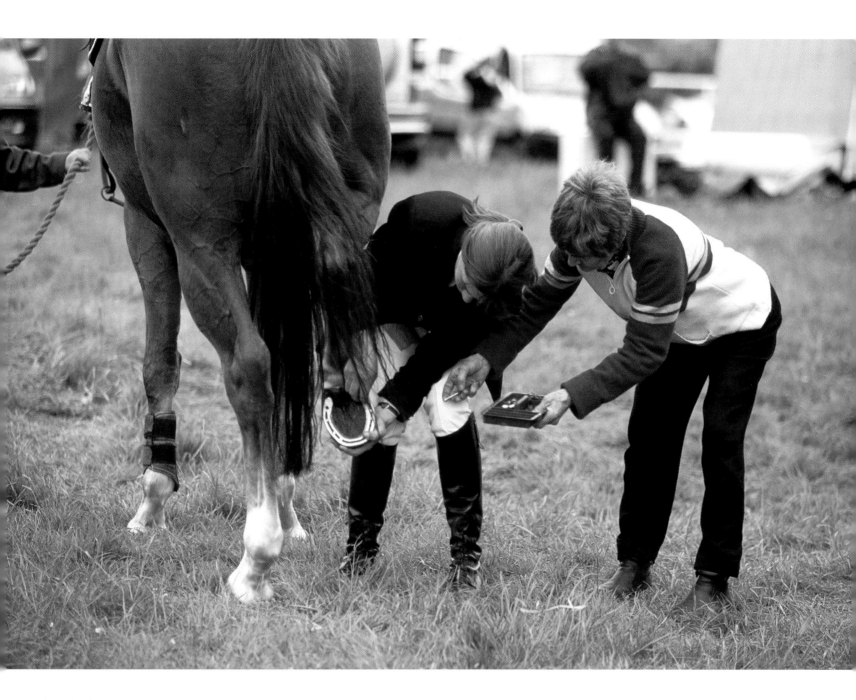

♠ Checking the hoof of a pony before a competition at Tralee Pony Show.

♦ Three yachts line up for the starting pistol to compete in one of two weekly sailing races in Tralee Bay.

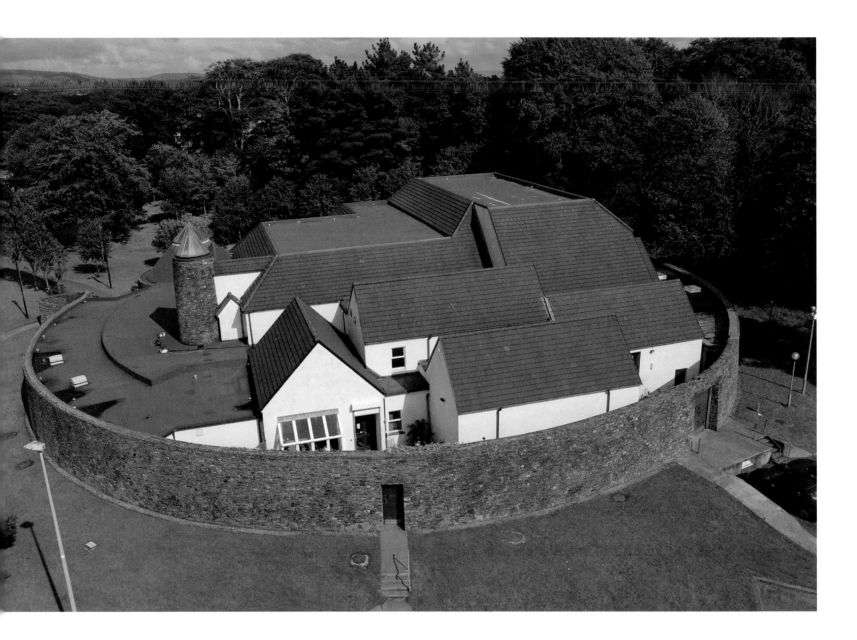

The Siamsa Tíre national folk theatre in Tralee.

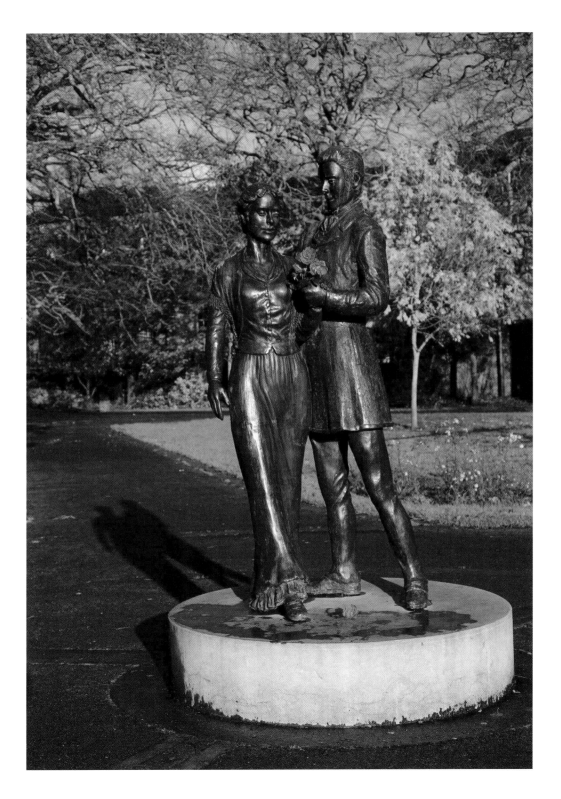

A sculpture in Tralee town park celebrates the Rose of Tralee Festival, depicting the love story of the first Rose of Tralee.

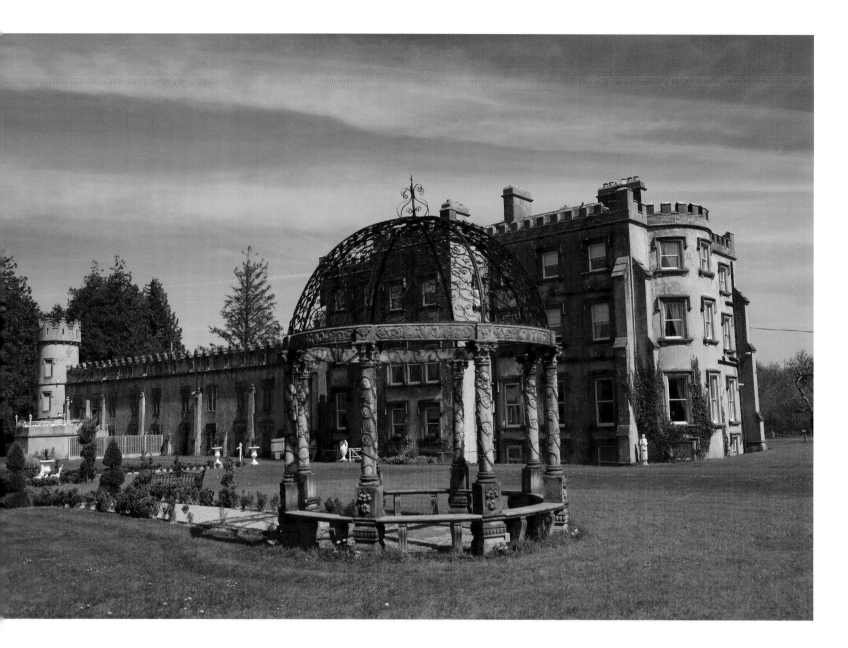

Ballyseedy Castle, once home of the Blennerhasset family, is now a hotel on the outskirts of Tralee.
Built in 1760 it is one of the few examples in Kerry of an extant eighteenth-century house.

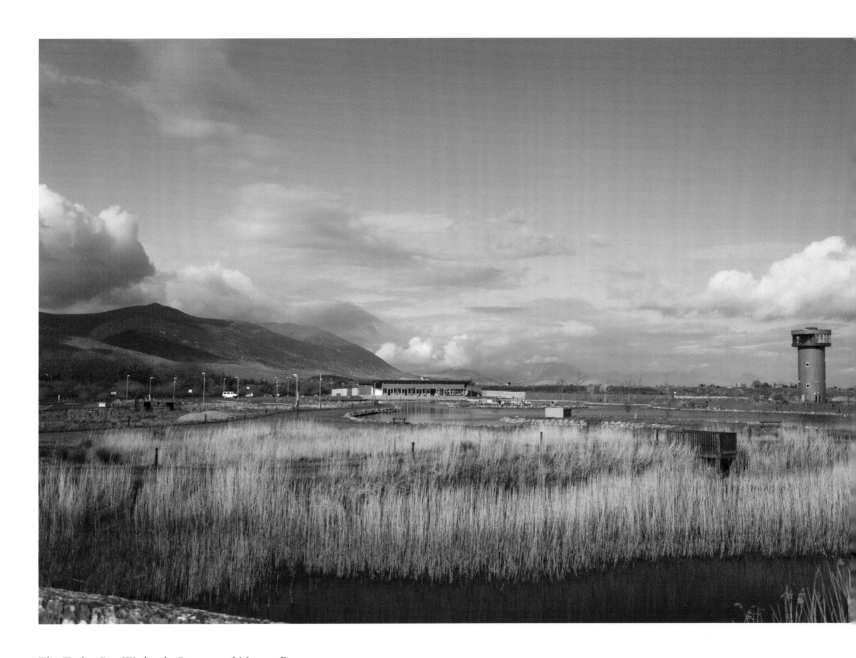

The Tralee Bay Wetlands Centre and Nature Reserve.

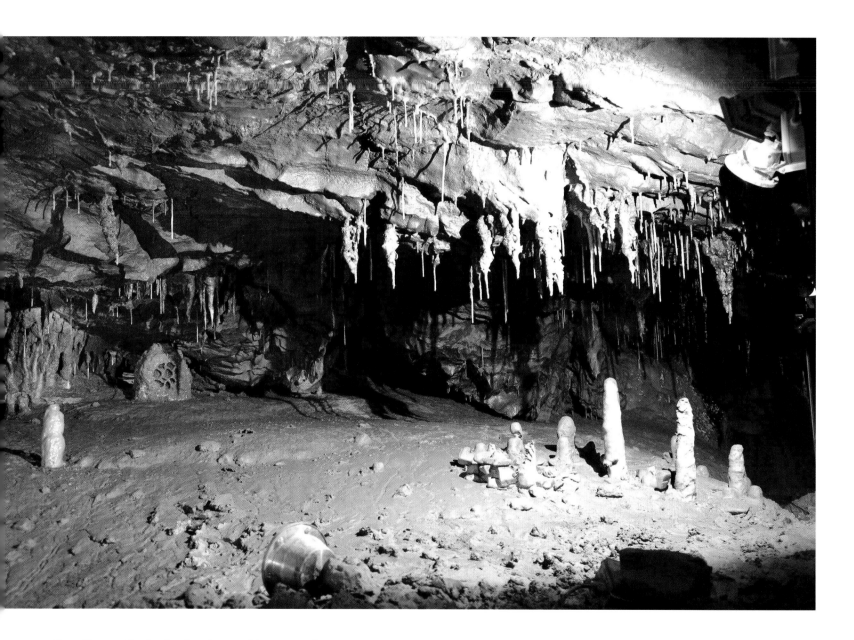

Crag Cave at Castleisland with typical limestone features.

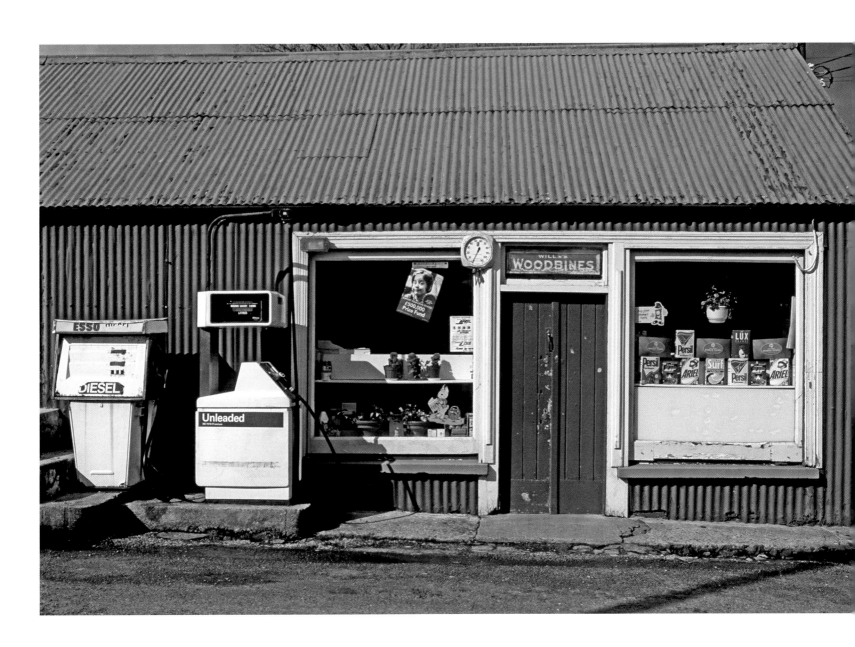

At Ballyfinnane Crossroads, near Farranfore, a once-thriving shop with petrol pumps, now sadly closed.

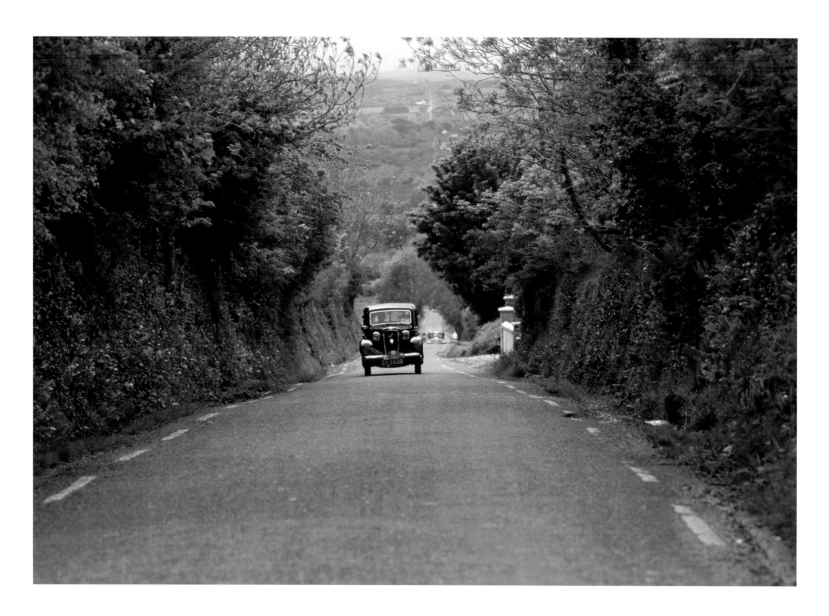

A vintage car ascends the hill climb at Ballyfinane on the old Tralee-to-Killarney road. The first classic race was organised by famous motor enthusiast Gordon Bennett.

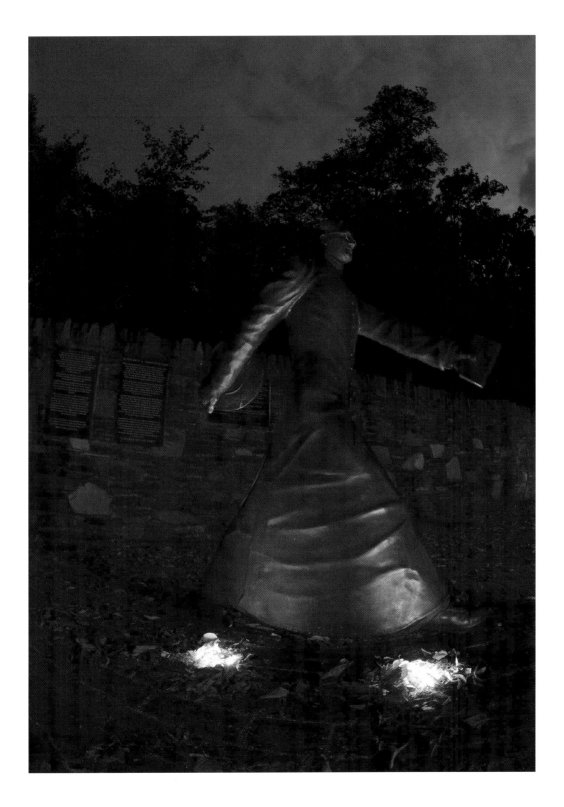

Sculpture of Monsignor Hugh O'Flaherty in Killarney. Known as 'the Scarlet Pimpernel of the Vatican', he is credited with saving thousands of lives in Rome during the Nazi occupation. His story is told in Brian Fleming's book, *The Vatican Pimpernel.*

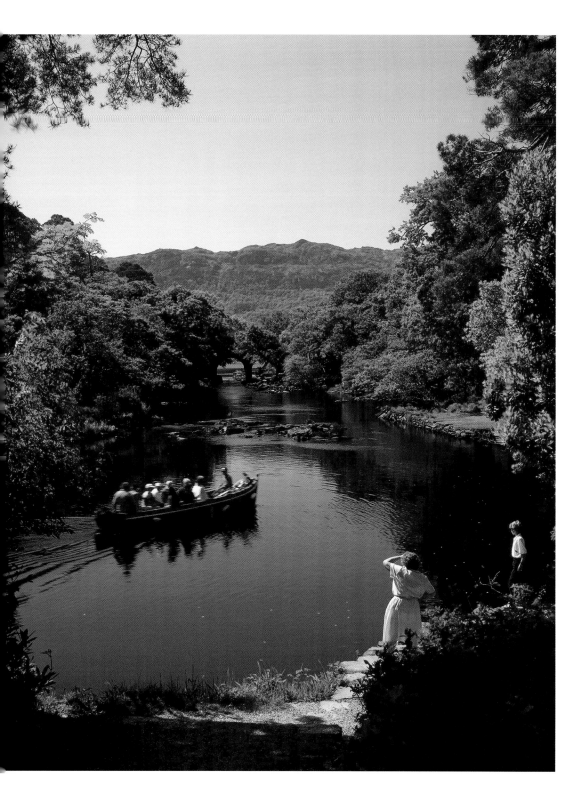

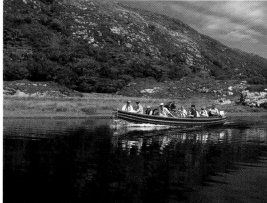

◆ The Meeting of the Waters:
tourists take a boat ride to
Lord Brandon's Cottage,
travelling through some
of the most spectacular
unspoiled landscape
that Ireland has
to offer.

🔺 Tourists being ferried
up through the waterway
from Ross Castle to
Lord Brandon's
Cottage, Killarney.

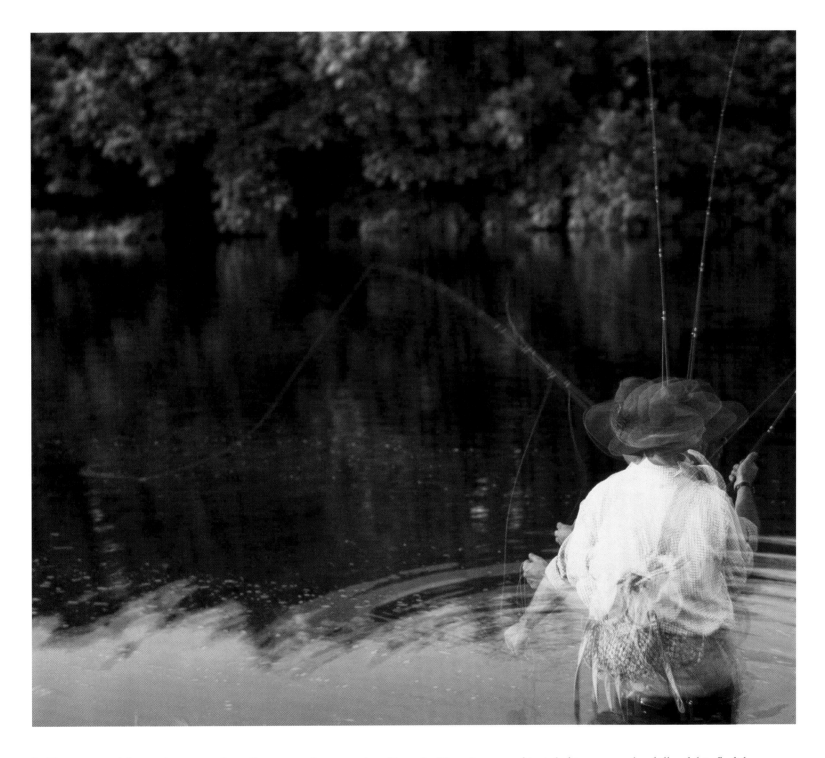

In Kerry, rivers, lakes and sea provide endless scope for recreation. Here the River Laune and its inhabitants test the skills of this fly-fisherman.

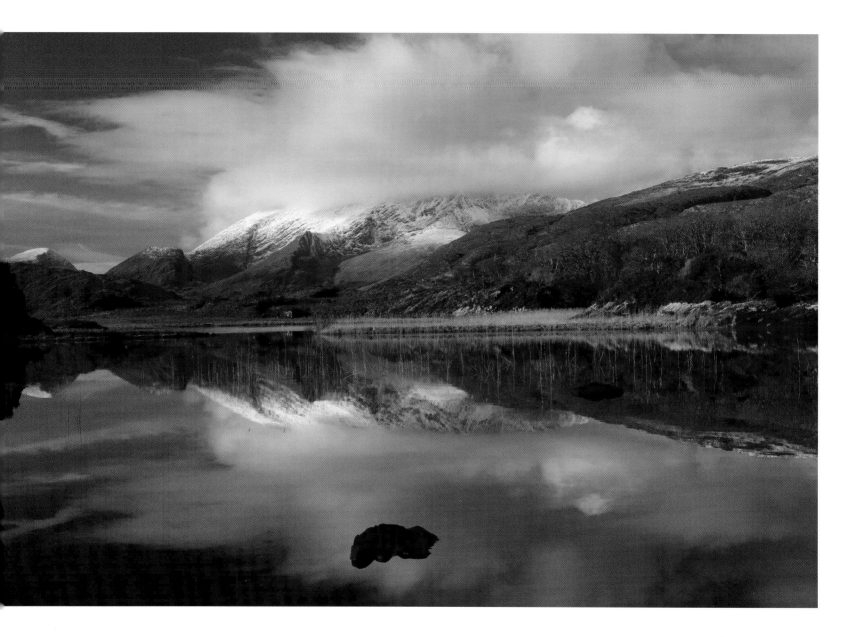

Killarney National Park in winter: a calm Upper Lake gives a perfect reflection of the surrounding mountains.

◀ The Kerry spotted slug,
found on the trunks
of forest trees, is
native to Killarney
National Park.

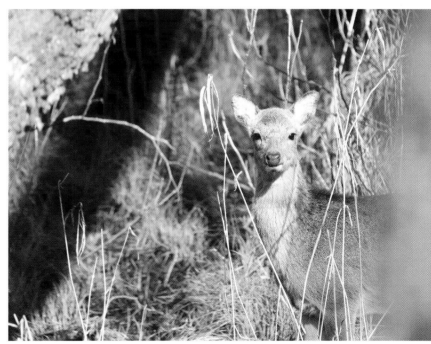

▲ A young Sika deer peers through forest vegetation
at Killarney National Park.

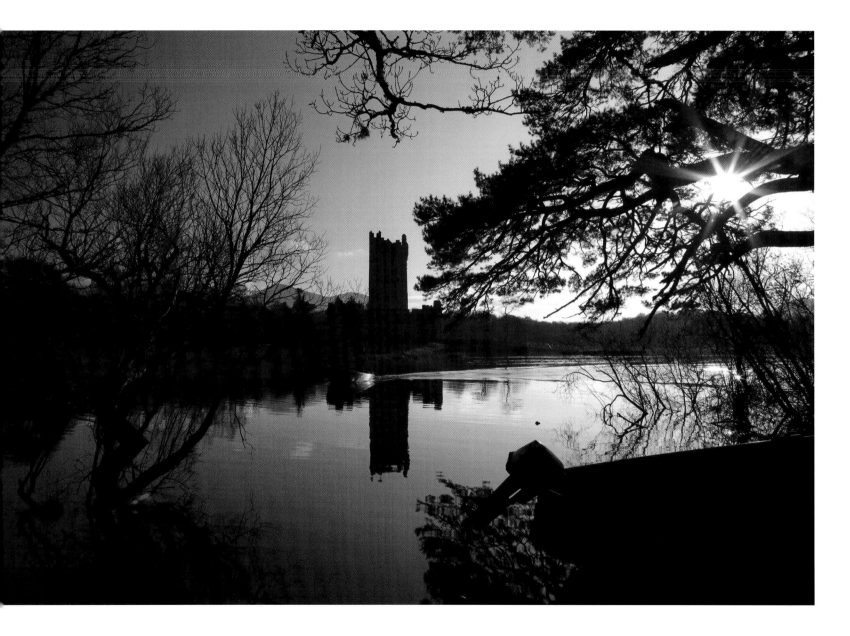

Evening at Ross Castle on Lough Leane, as a small fishing boat approaches.

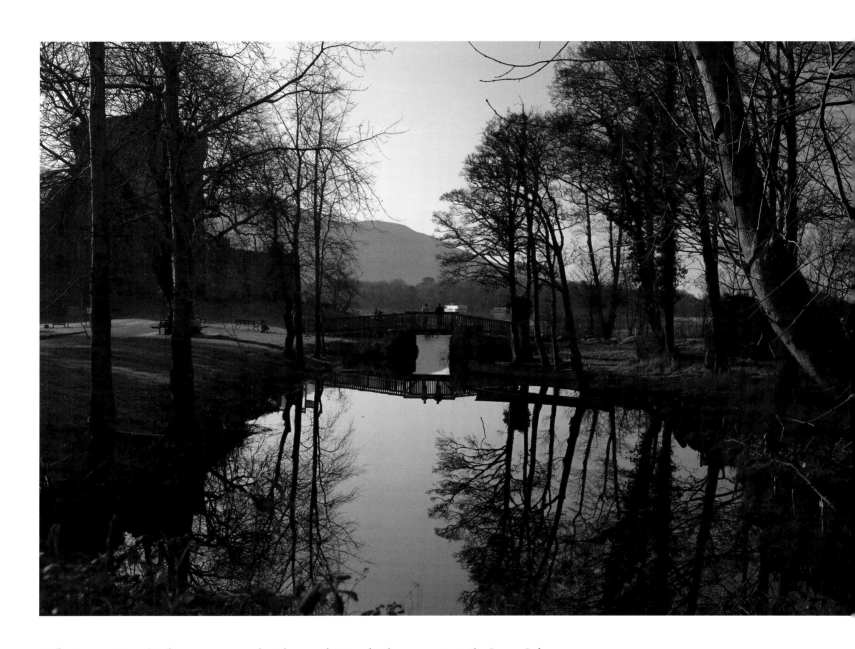

Reflections at Ross Castle: a narrow canal under a pedestrian bridge connects to the Lower Lake.

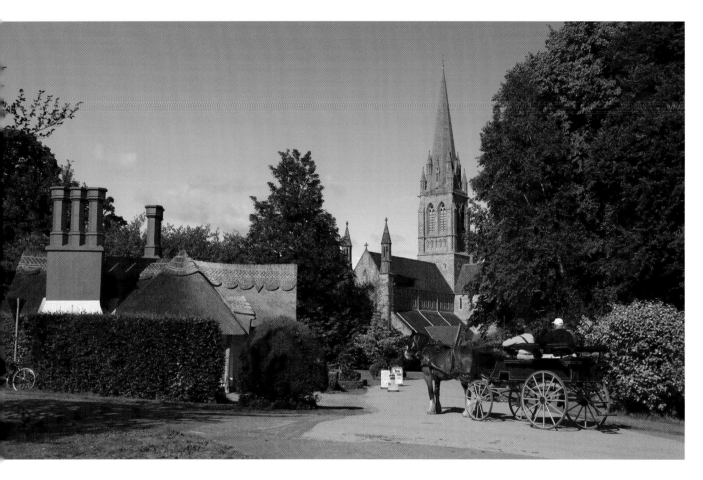

St Mary's Cathedral in Killarney lies just beyond
the entrance to the National Park. The thatched
cottage on the left, Deenagh Lodge,
houses a restaurant.

Jaunting cars travel along the pathways and roads
of Killarney National Park, showing tourists
the hidden gems.

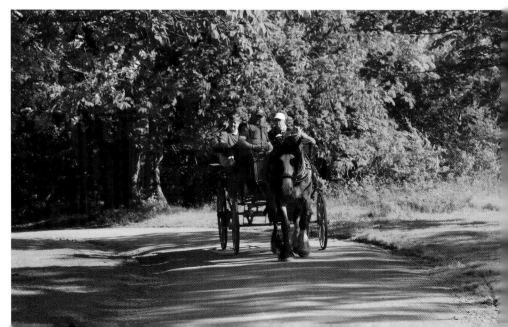

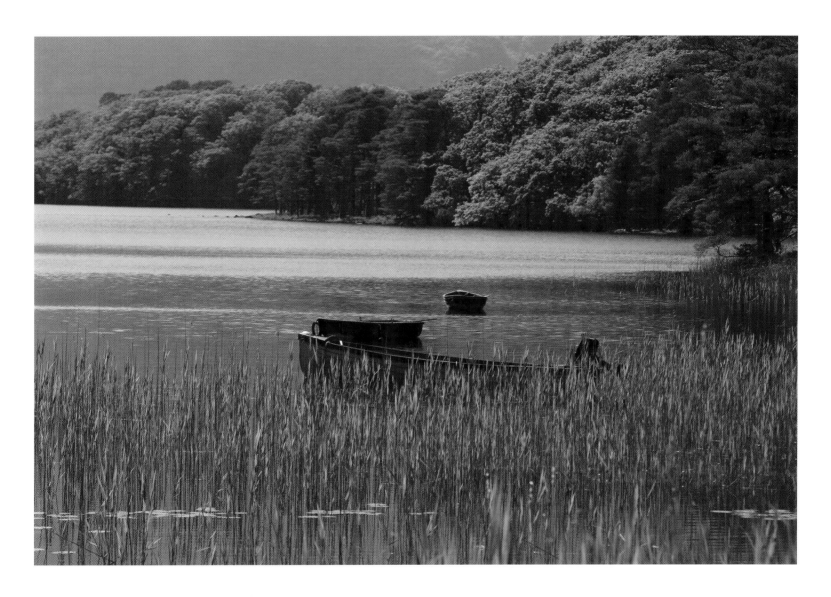

Muckross Lake in Killarney National Park.

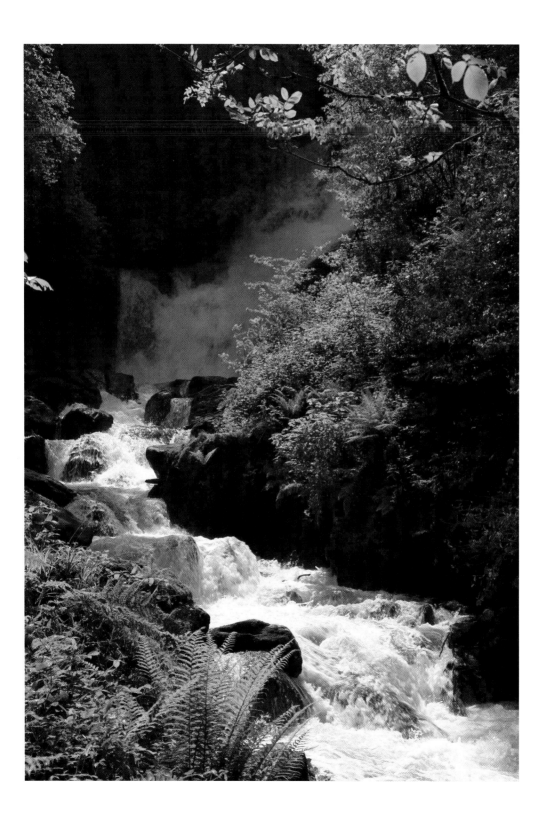

Torc Waterfall
in Killarney National Park.

Killarney National Park bursting with spring colours.

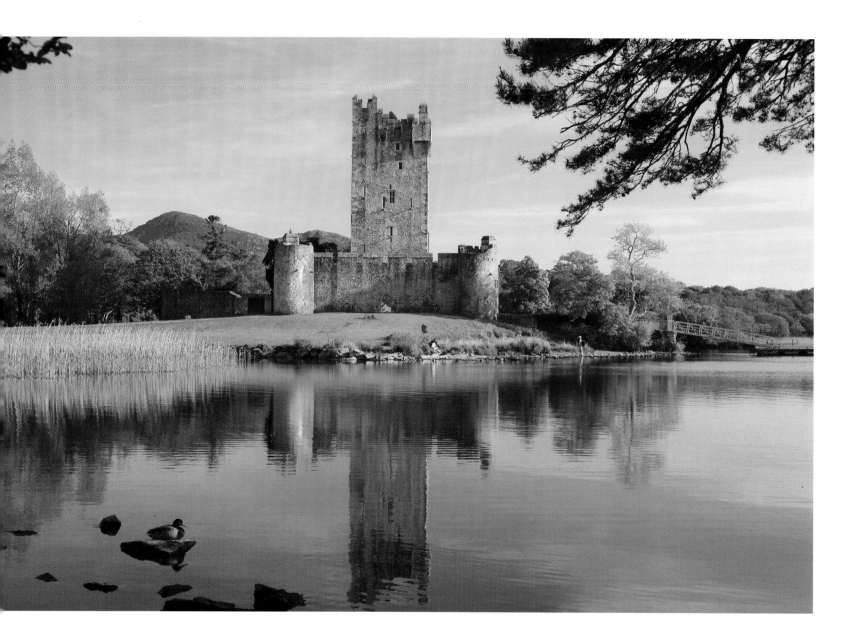

Ross Castle, a stronghold of the O'Donoghue Clan in the fifteenth century, on the shores Lough Leane.

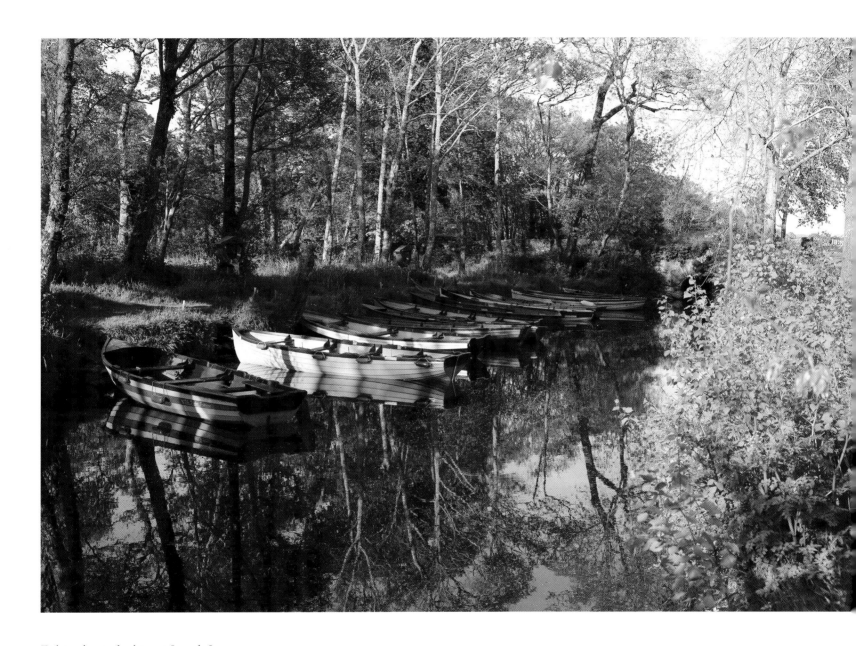

Fishing boats for hire at Lough Leane.

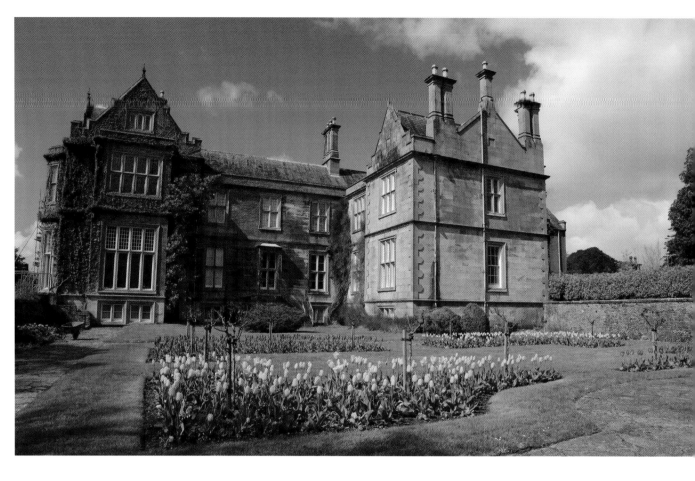

⬆ Nineteenth-century Muckross House in Killarney National Park.

⬅ A profusion of rhododendron colour in the gardens of Muckross House in spring.

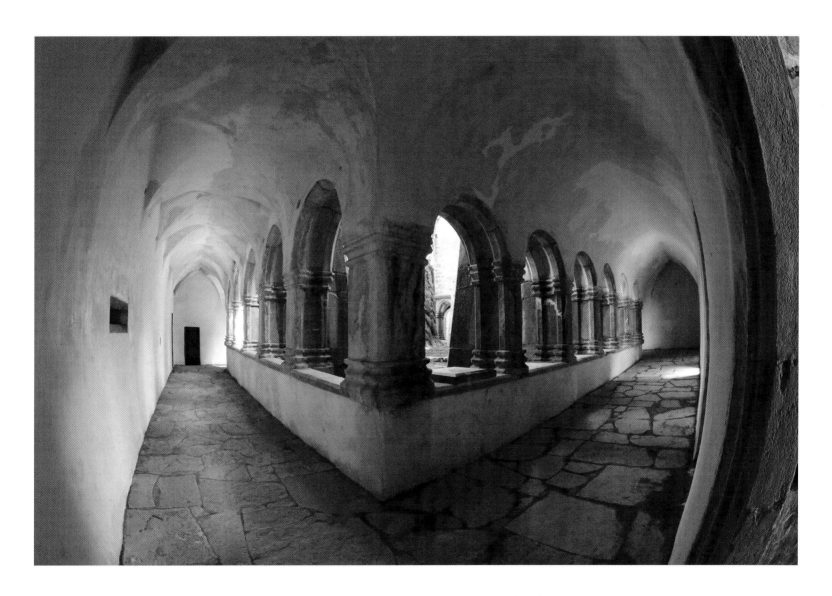

The cloisters of Muckross Abbey, a fifteenth-century Franciscan friary in Killarney National Park.

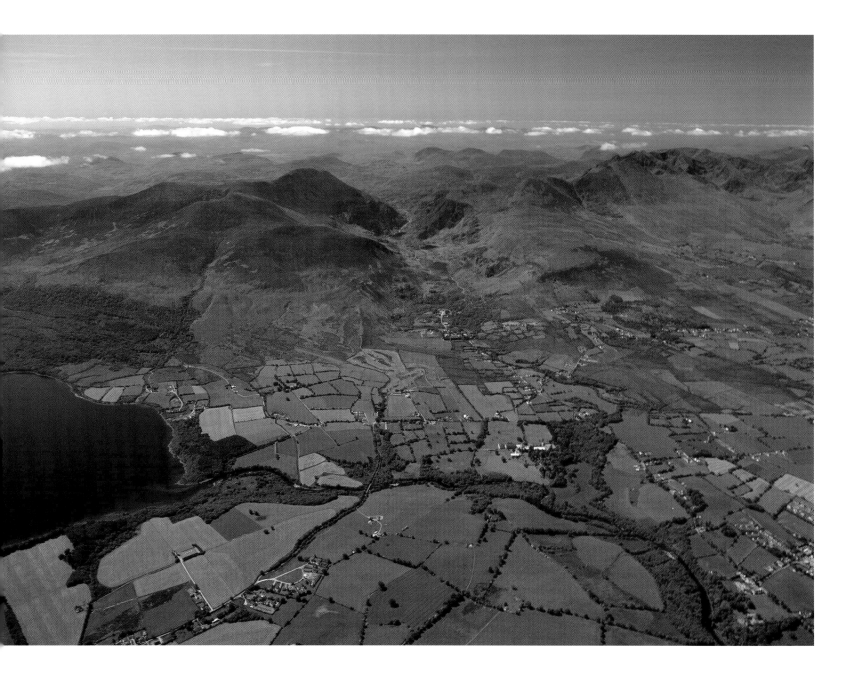

An aerial view of Lough Leane (left), the MacGillycuddy's Reeks and the Gap of Dunloe.

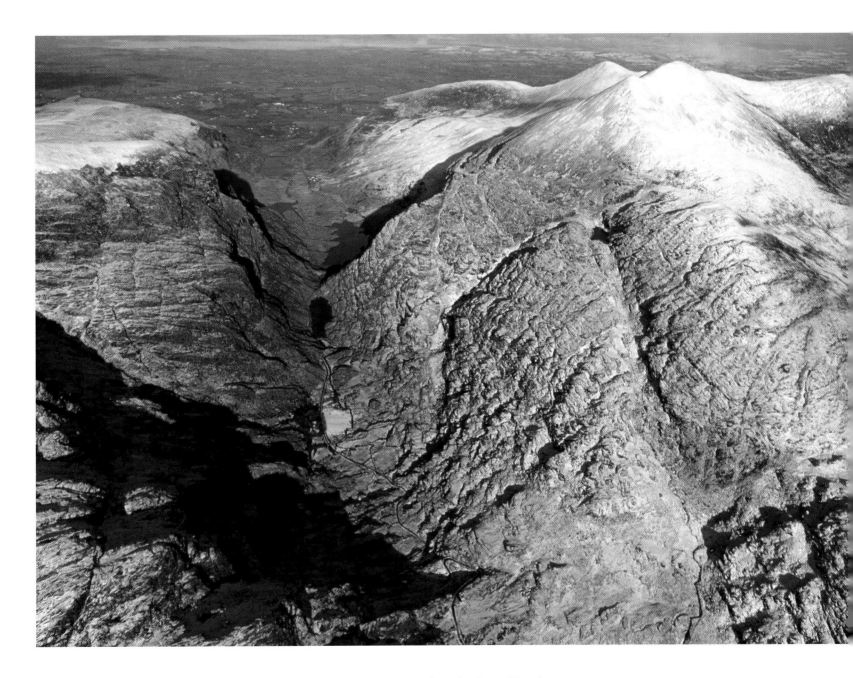

Winter snow highlights the contours and layout of the landscape surrounding the Gap of Dunloe.

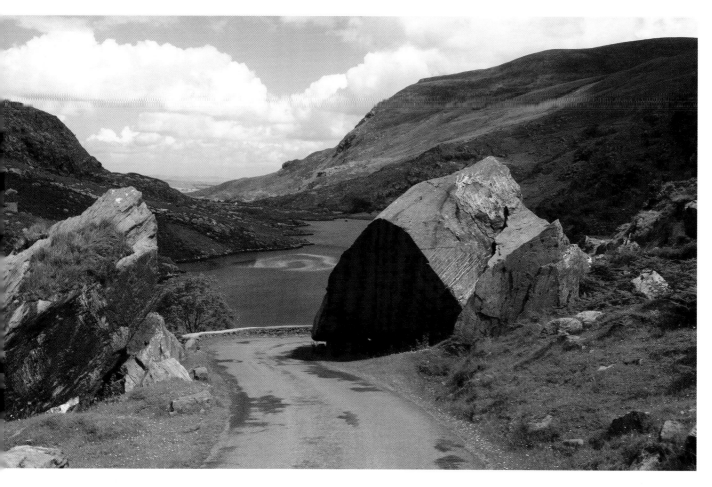

♠ The famous landmark of Turnpike
Rock in the Gap of Dunloe,
with Auger Lake behind.

➡ Muckross Lake and Tomies Mountain
form the backdrop for these two cyclists
in Killarney National Park.

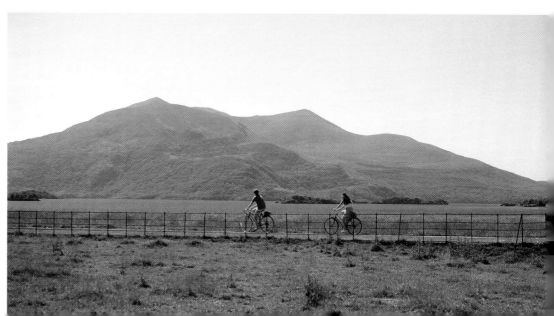

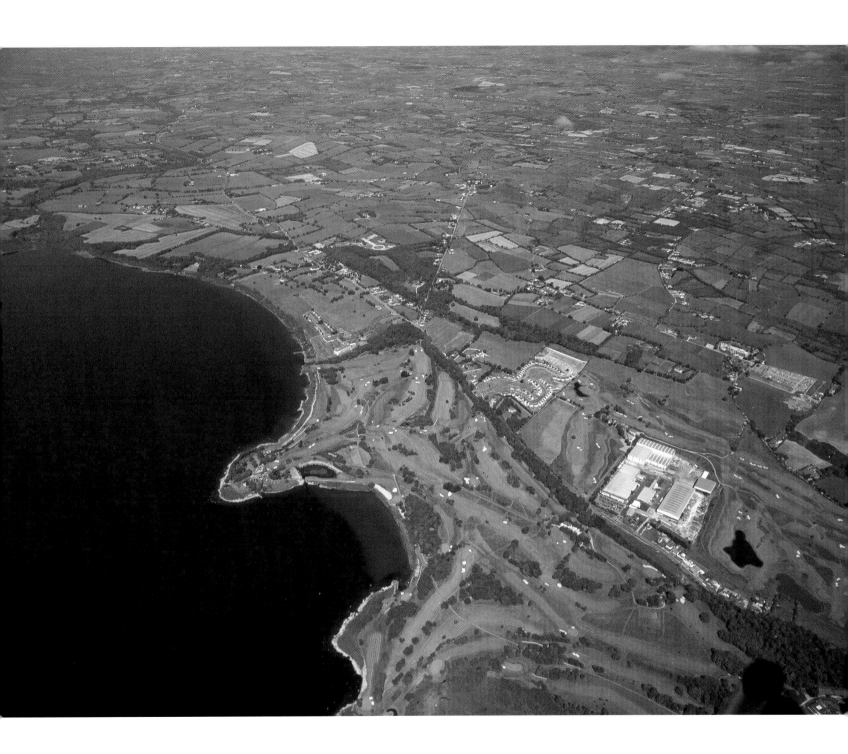

An aerial view of Lough Leane with the Killarney Golf and Fishing Club, and the Liebherr crane factory.

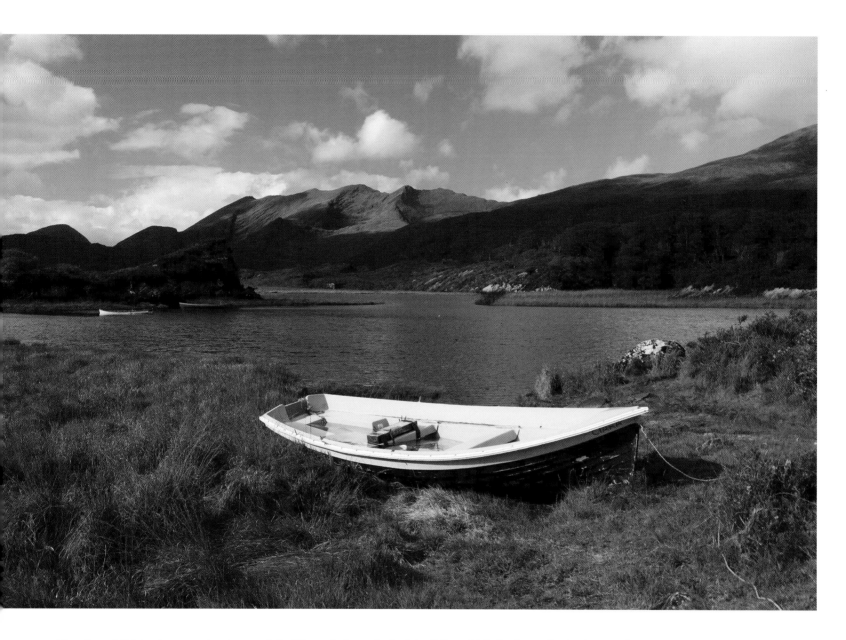

Abandoned fishing boat on the shores of the Upper Lake with the MacGillycuddy's Reeks in the background.

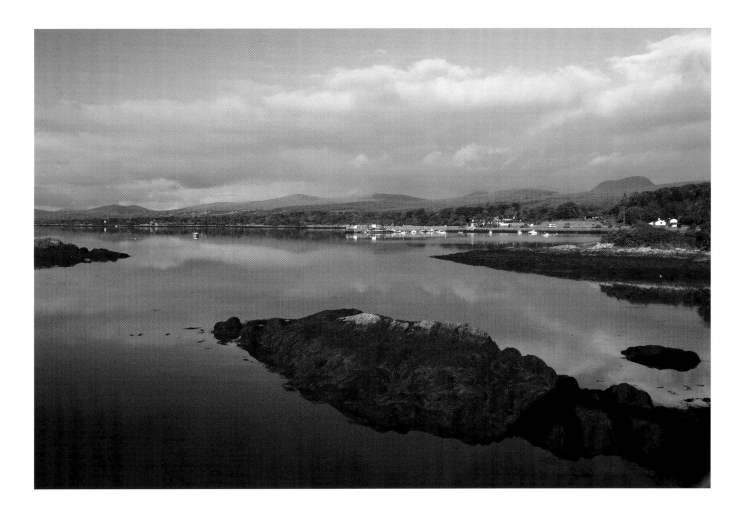

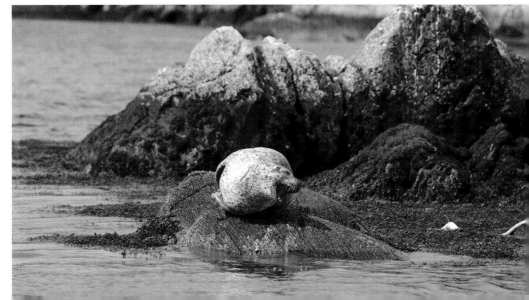

↟ The Kenmare River in the calm
of early morning.

➡ A grey seal on a rock outcrop
in the Kenmare River.

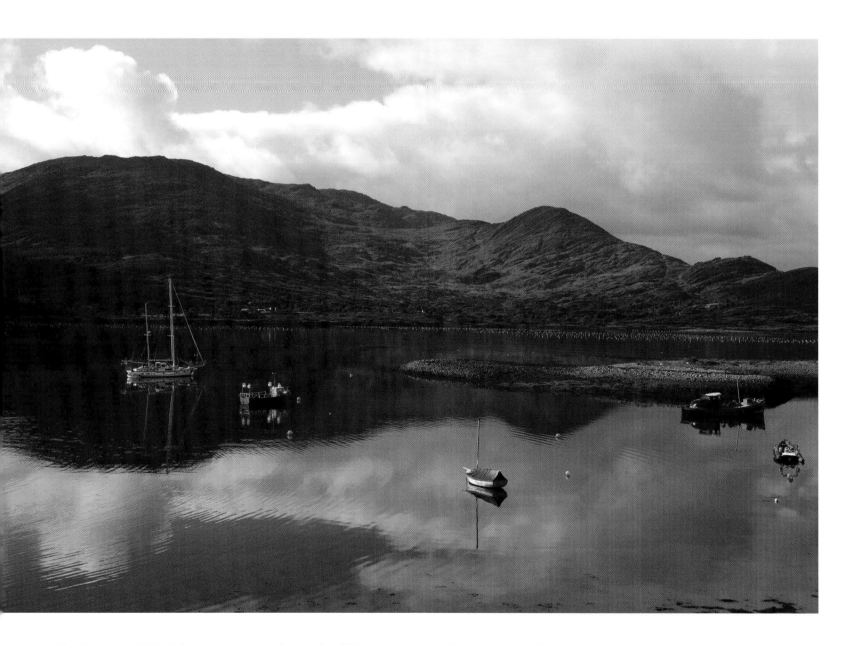

The harbour at Kilmakillogue, on the southern side of Kenmare River on the Beara Peninsula.

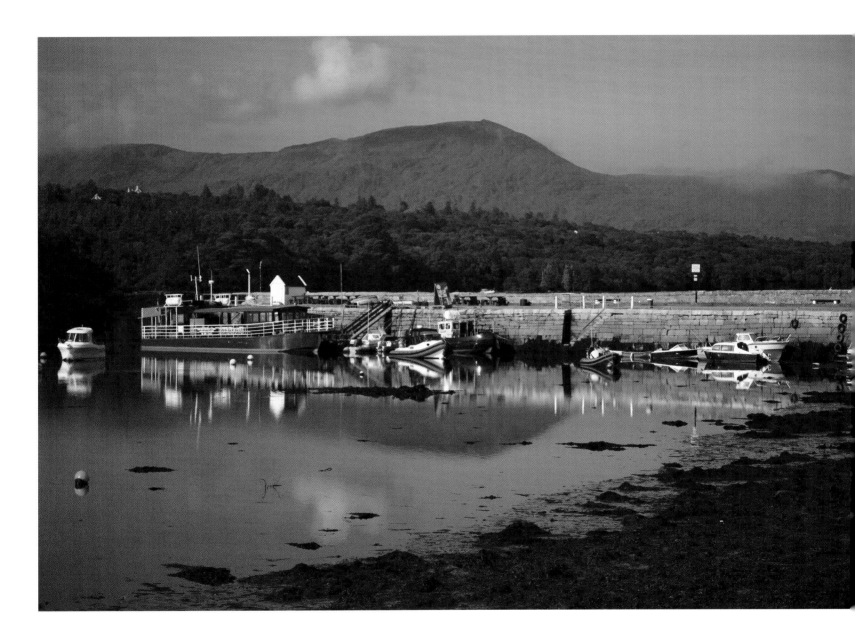

A pier on the Kenmare River with a colourful array of boats.

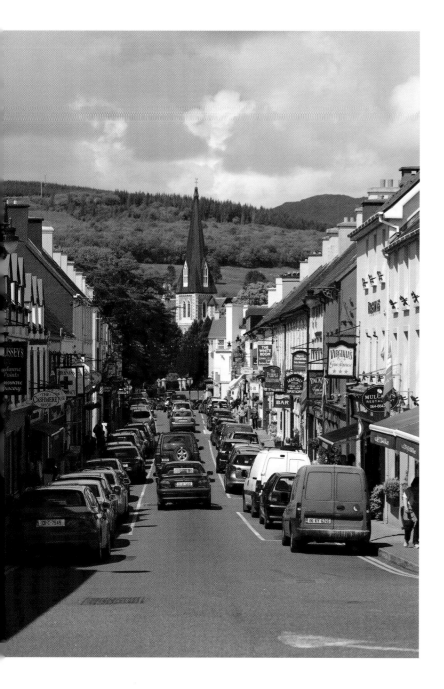

Molly Galvin's, a refurbished ➤
roadside shop near Kenmare.

◀ Kenmare town centre with the church
steeple dominating the skyline.

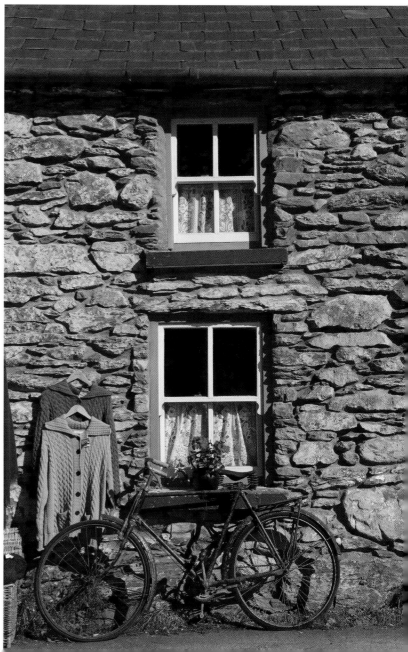

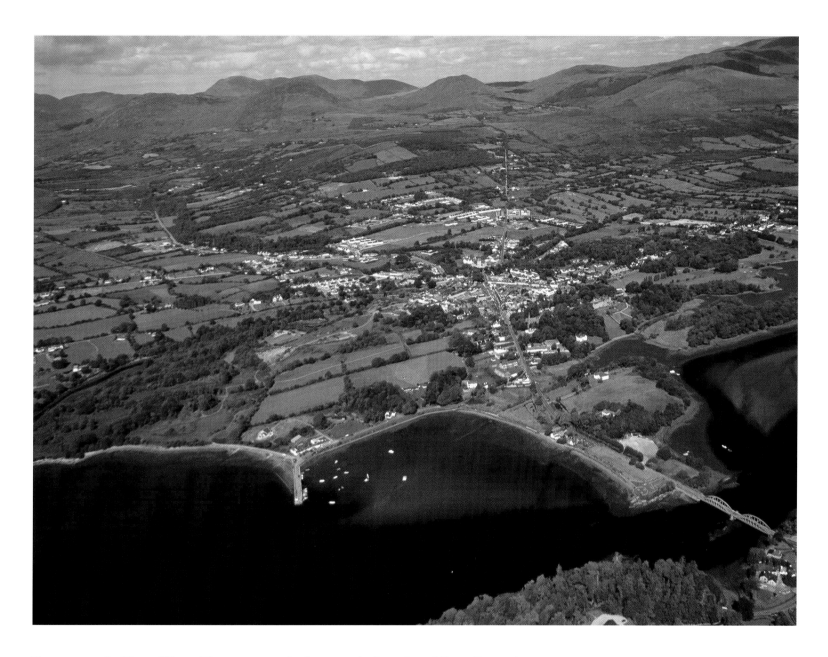

Kenmare on the Ring of Kerry. The suspension bridge joins the Iveragh and Beara Peninsulas.

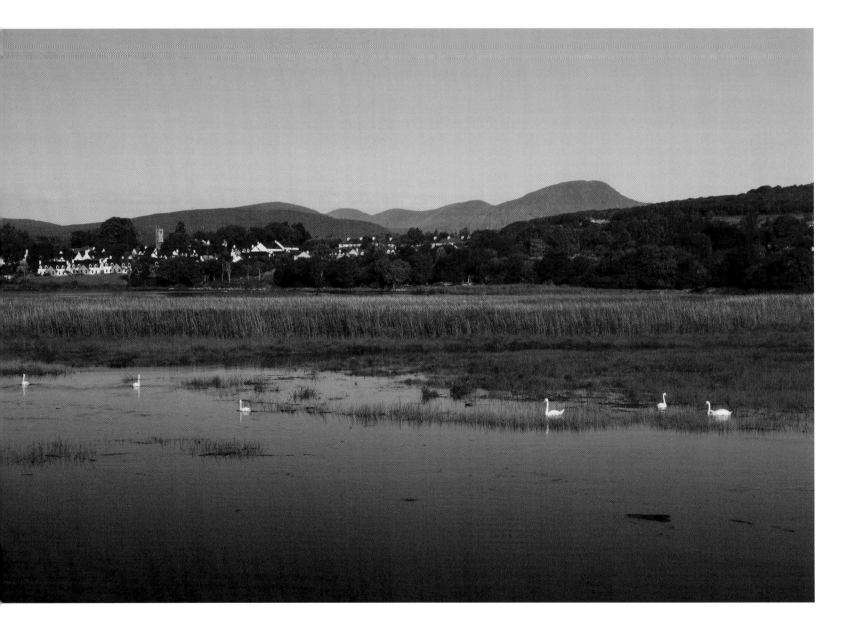

Swans in the estuary near Sheen Falls, Kenmare.

A farmhouse tucked away under ➤
the Caha Mountains on the shores
of Glanmore Lake.

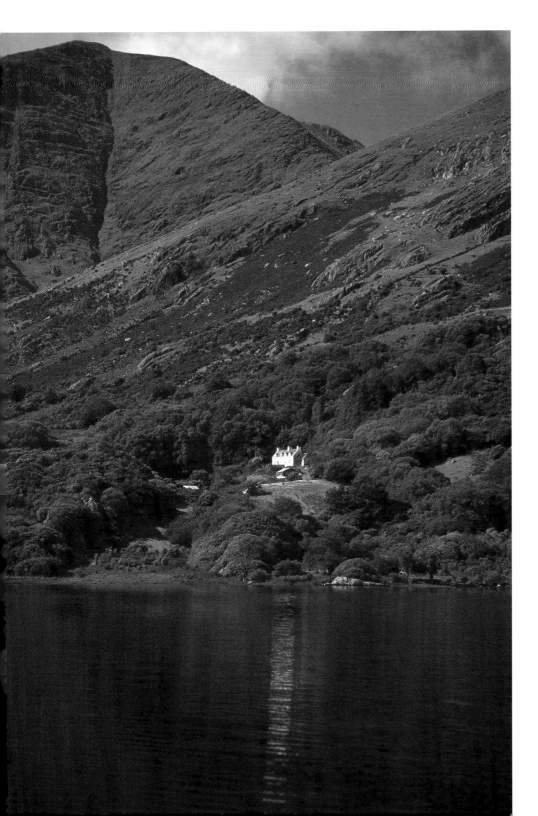

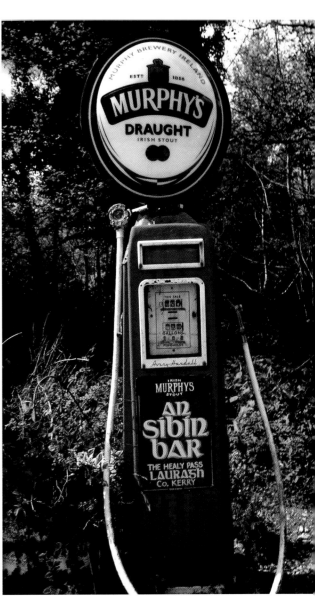

▲ Advertisement for the Síbín Bar
at the end of the Healy Pass on an old
petrol pump, near Lauragh.

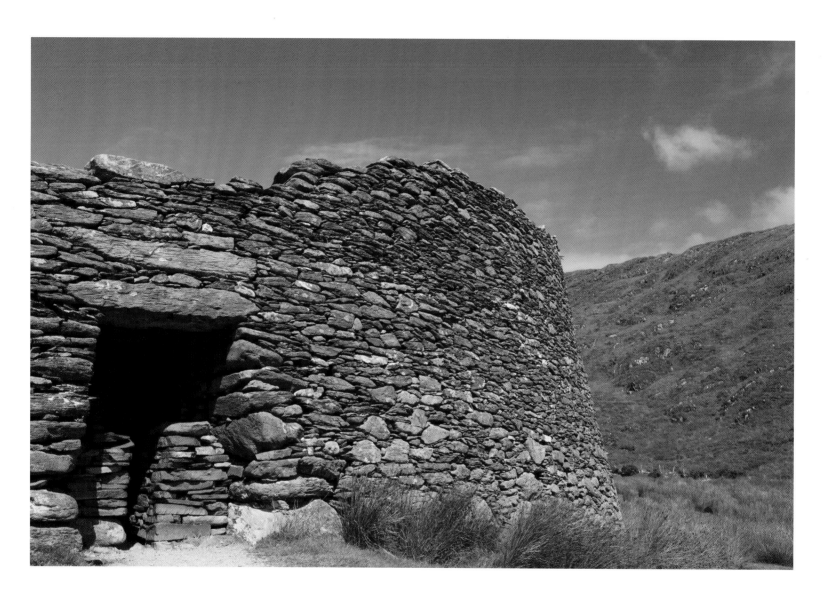

Staigue Fort, at the end of an isolated valley near Sneem, is a circular stone structure dating back to the Iron Age.

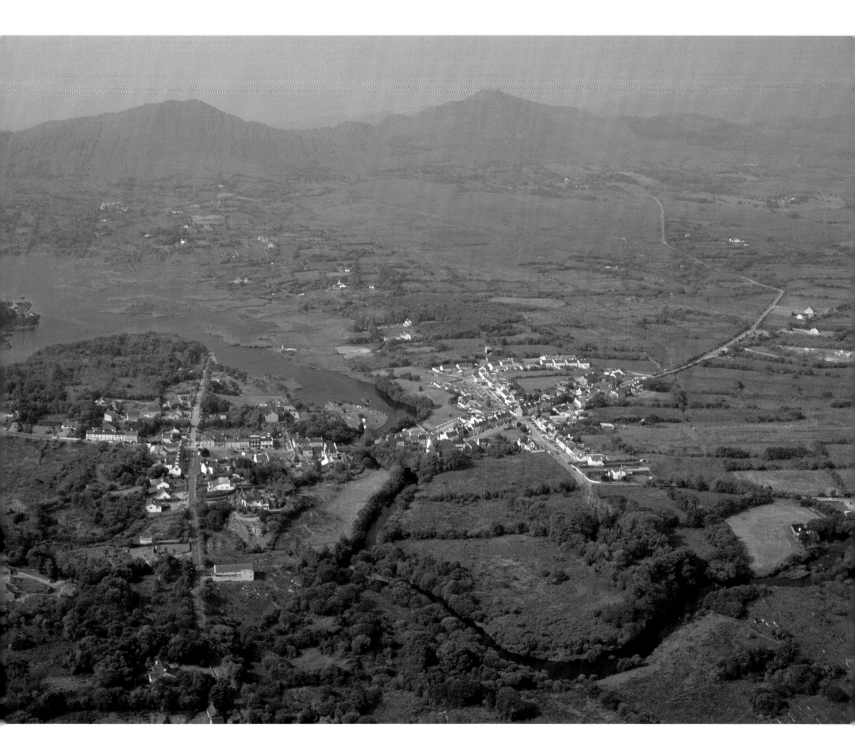

Aerial view of Sneem on the Ring of Kerry. The village is divided in two by the Sneem River, which flows into the Kenmare River.

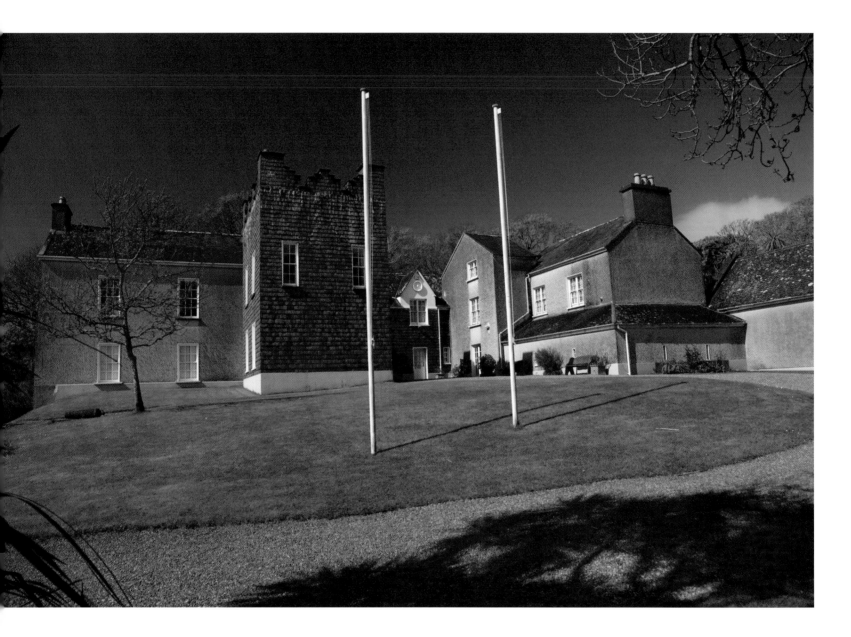

Derrynane House, ancestral home of The Liberator, Daniel O'Connell (1775–1847). It is open to the public.

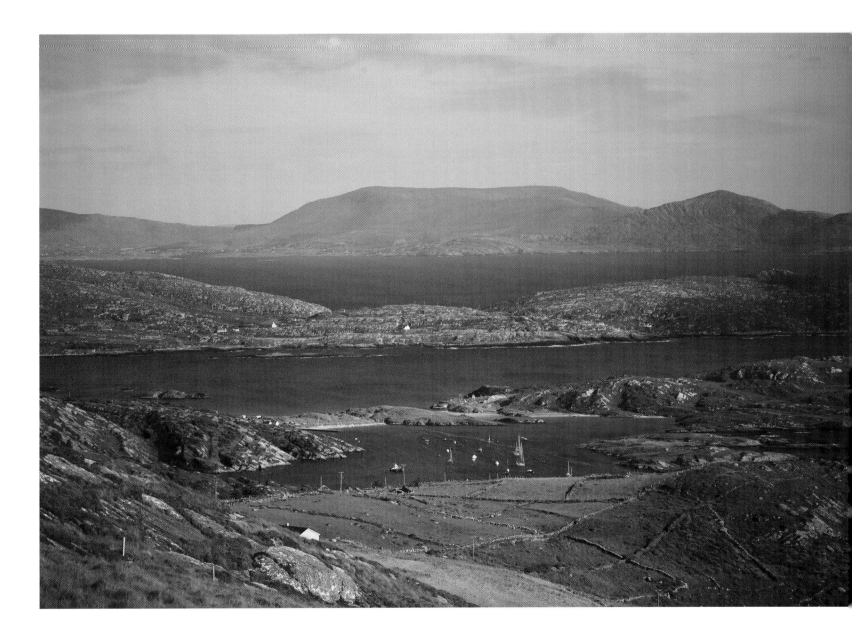

Derrynane Harbour on the Kenmare River with the Beara Peninsula filling the horizon.

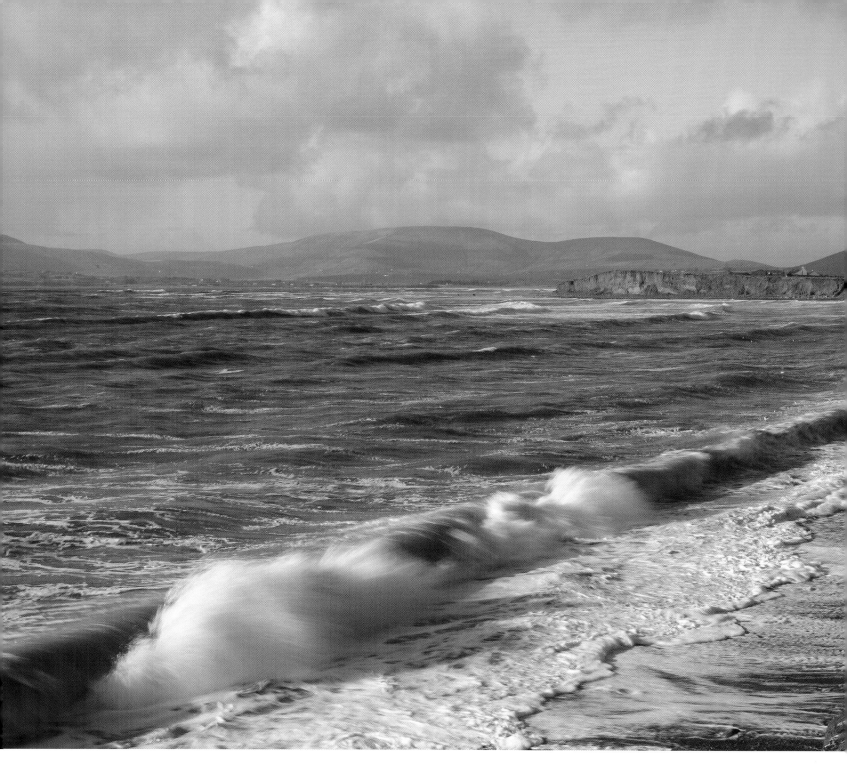

⬆ Ballinskelligs Bay near Waterville on the Ring of Kerry.

➡ The sculpture at Waterville of one of Kerry's great footballers, Mick O'Dwyer.

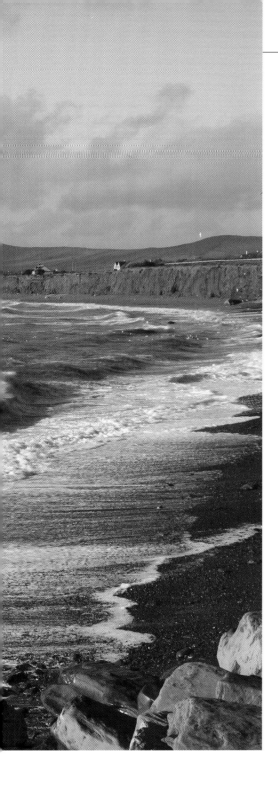

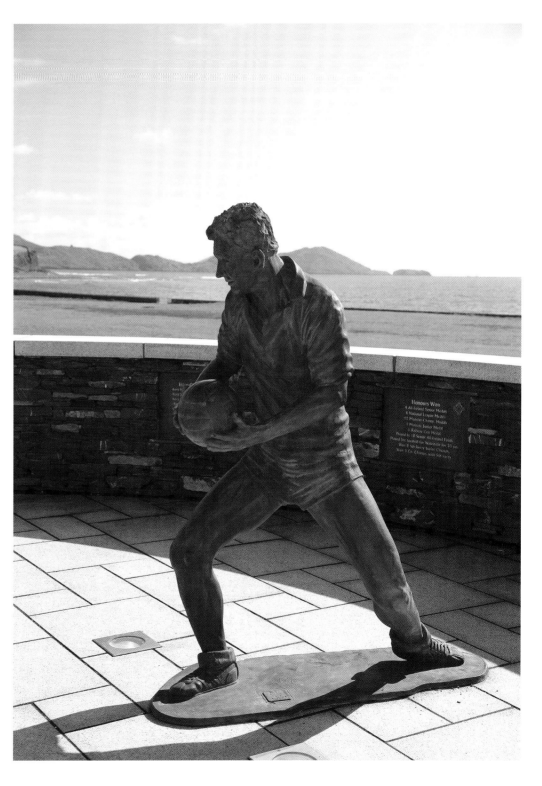

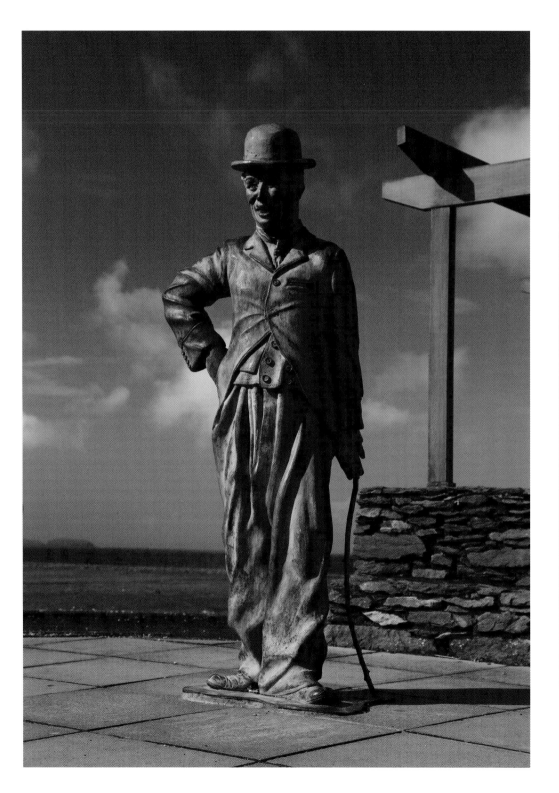

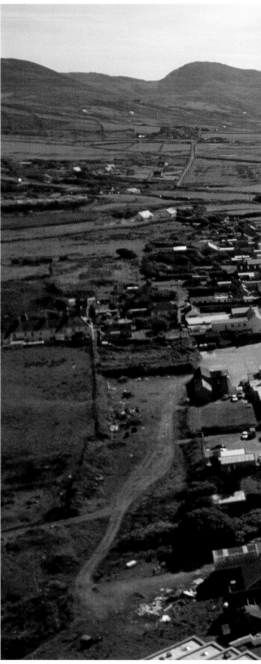

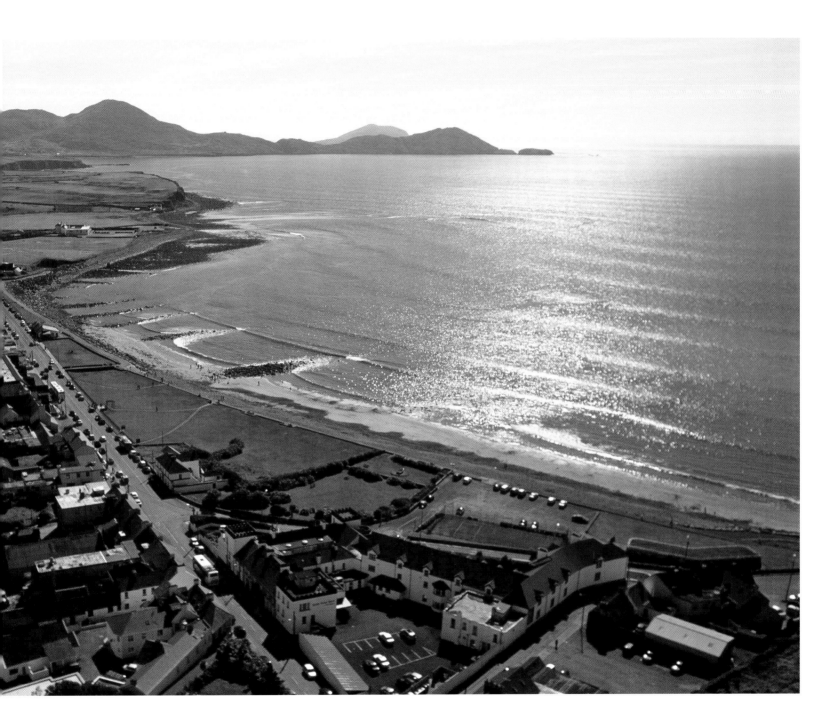

▲ Waterville, on Ballinskelligs Bay, was once the hideaway of Charlie Chaplin and family, and the birthplace of footballer Mick O'Dwyer.

◆ The bronze statue of the world-famous comic actor and entertainer Charlie Chaplin (1889–1977) in Waterville town centre.

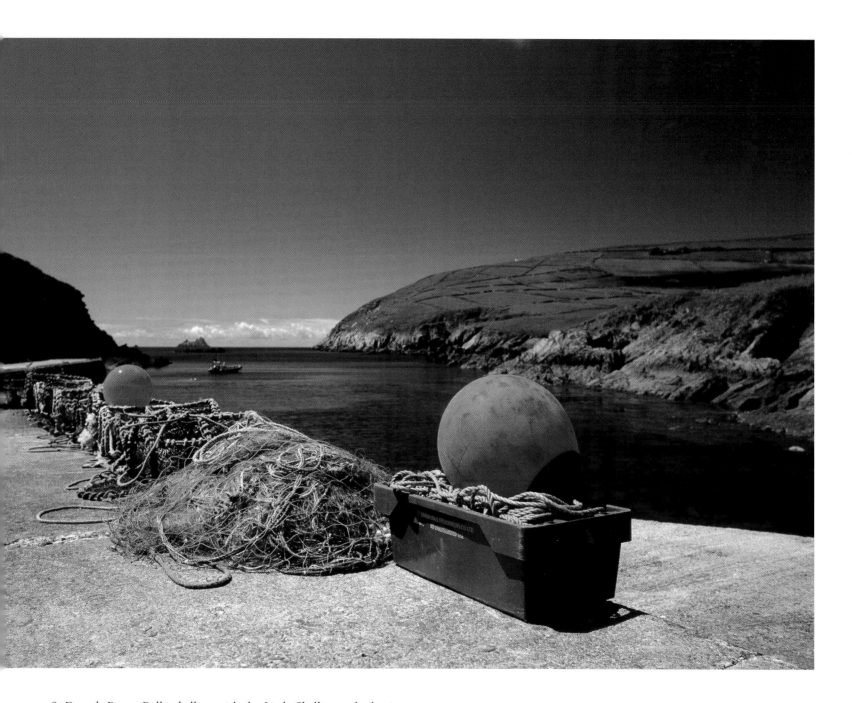

St Finan's Bay at Ballinskelligs, with the Little Skellig on the horizon.

A rusted corrugated-iron roofed dwelling, now abandoned, stands forlorn in the middle of stone-walled fields in summer.

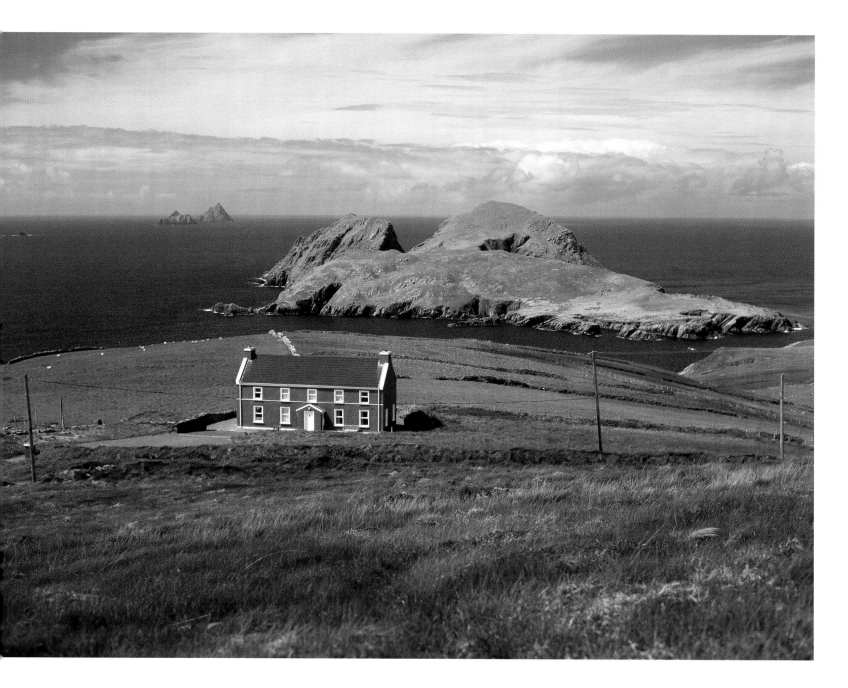

The bird sanctuary of Puffin Island in St Finan's Bay, with the Skellig Islands on the horizon.

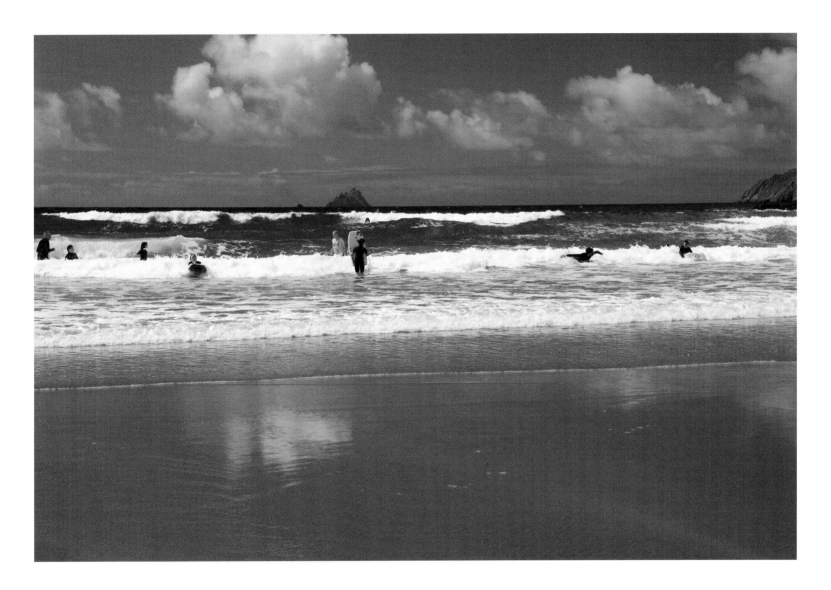

At St Finan's Bay, people enjoy the surf, with the wild Atlantic and Skellig Islands in the background.

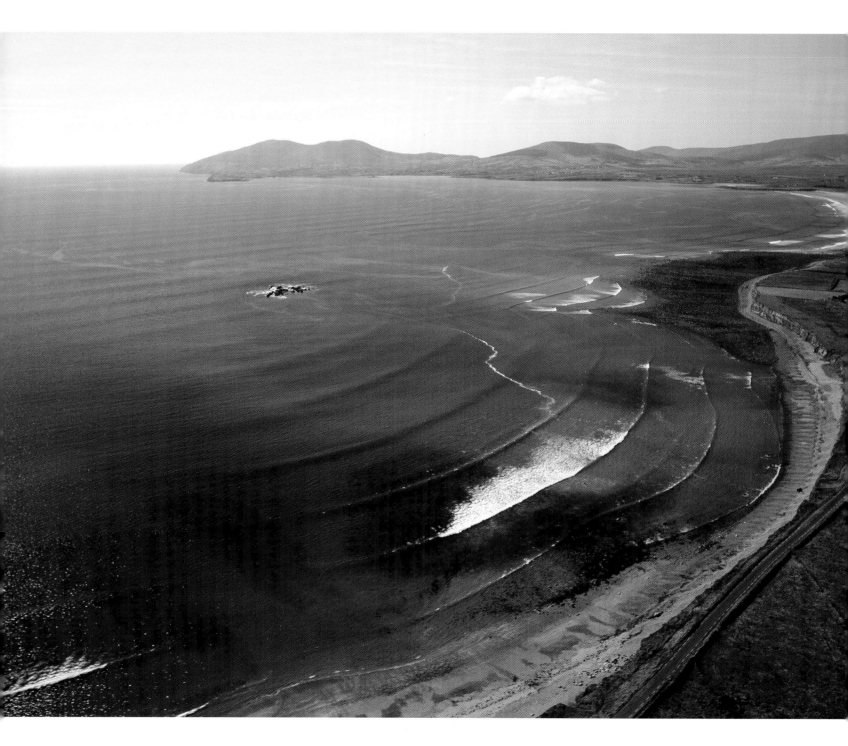

Ballinskelligs Bay near Waterville.

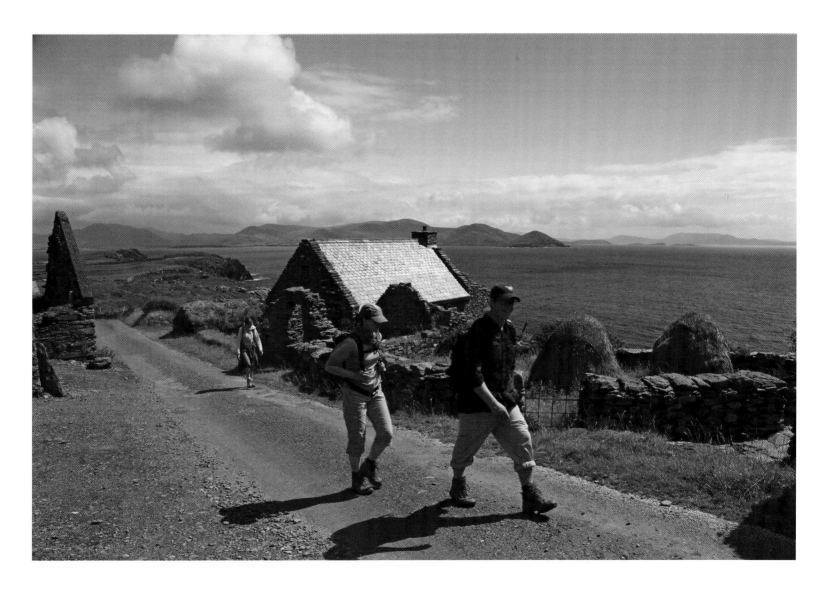

Walkers at a restored Famine village, Cill Rialaig, Ballinskelligs Bay.

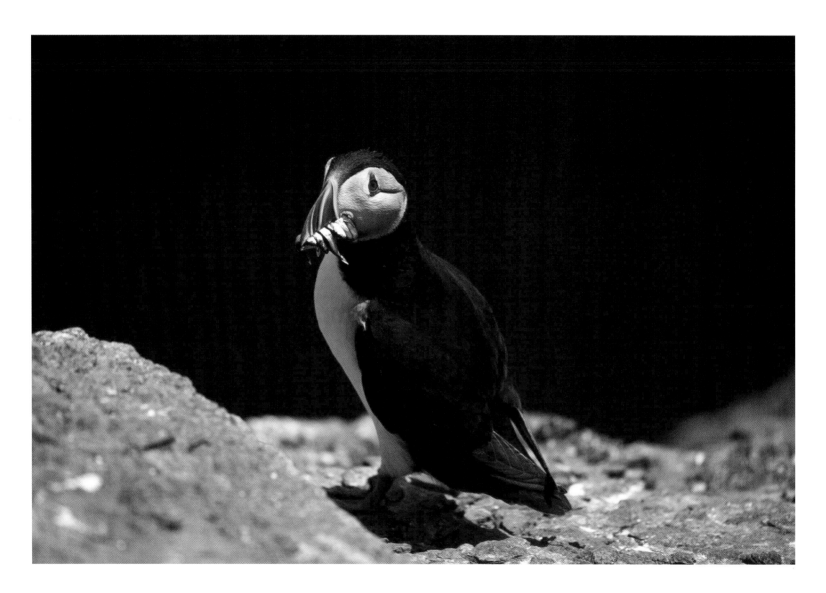

A puffin on Skellig Michael with a beakful of sand eels.

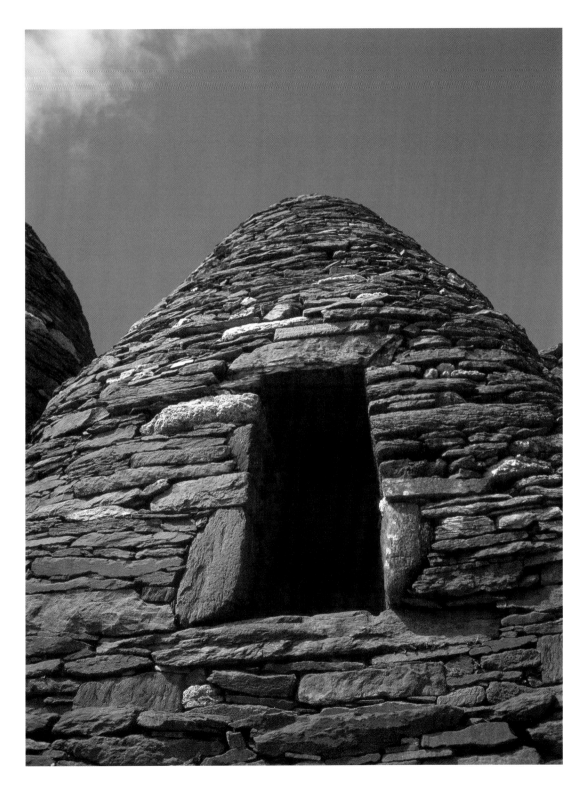

One of the monastic
beehive stone structures
on Skellig Michael,
situated almost 12km
out in the Atlantic.
Once a place of
penance, it is
now a UNESCO
heritage site.

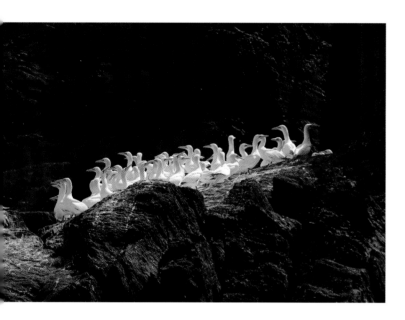

Little Skellig, one of two rocky outcrops off the tip of the
Iveragh Peninsula, is home to a large colony
of gannets and other seabirds.

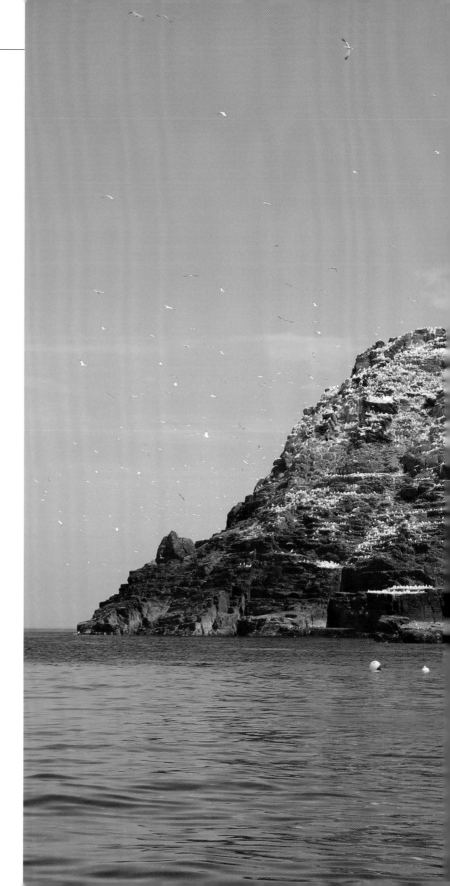

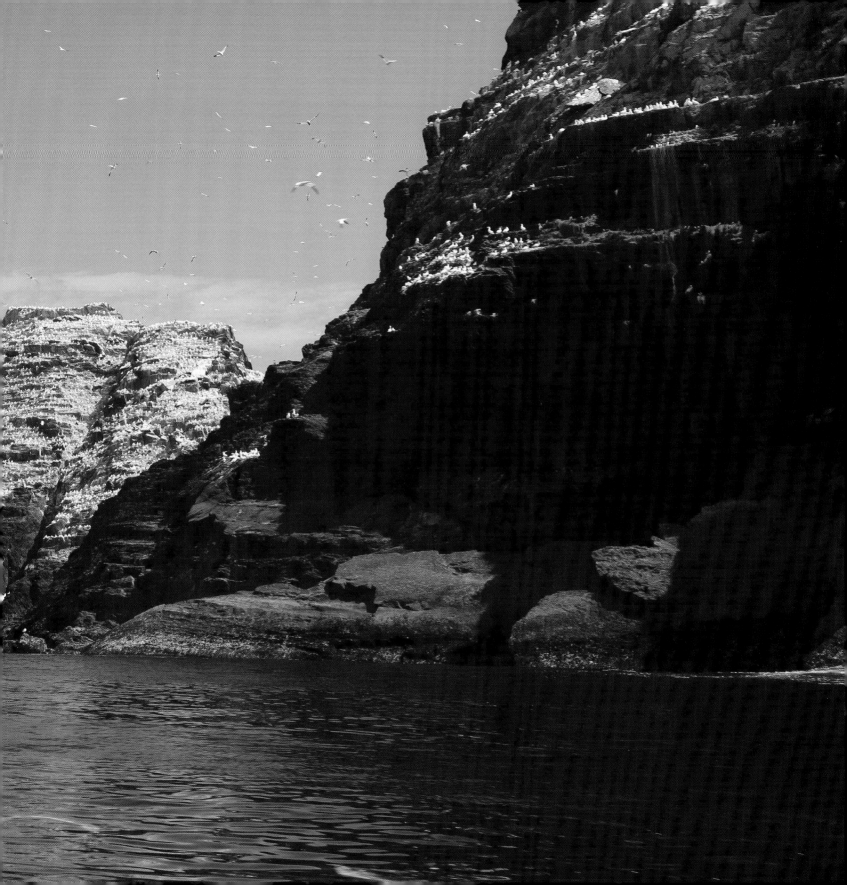

The path on Skellig
Michael from the
landing pier.

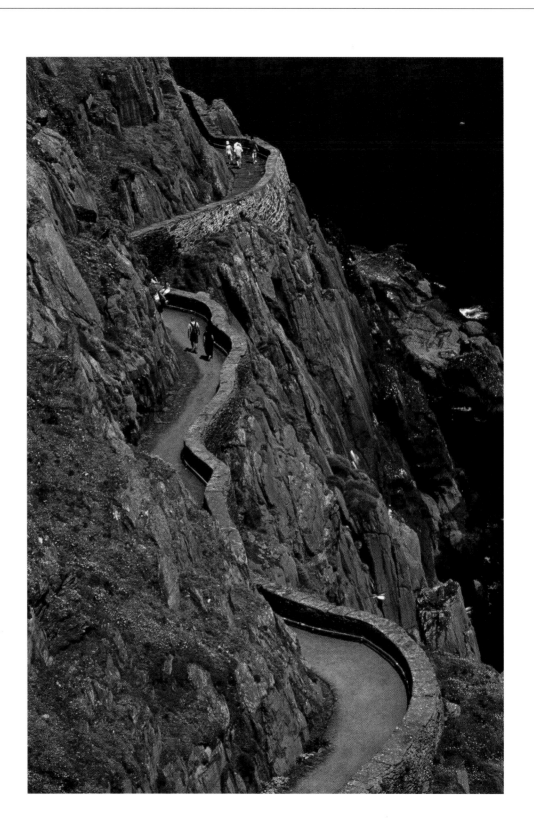

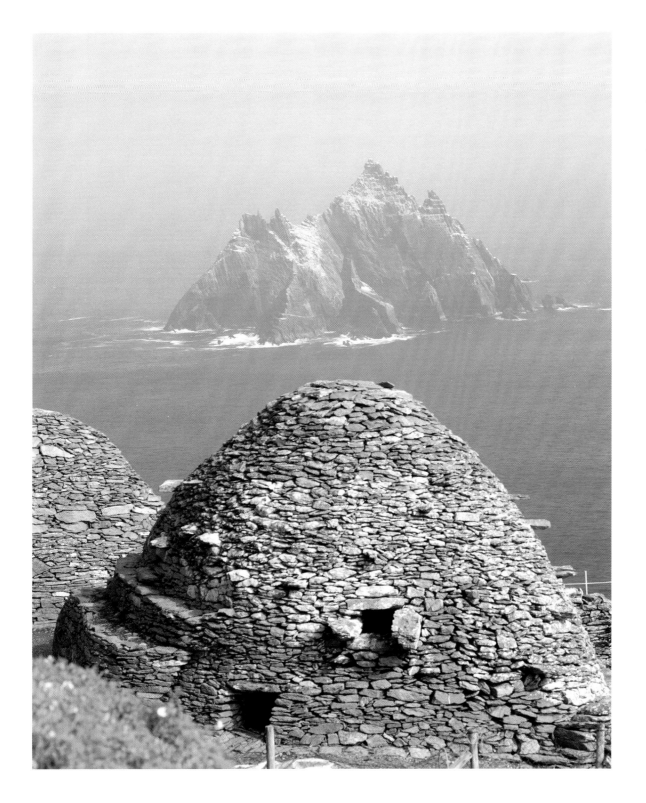

A beehive hut on Skellig Michael with the Little Skellig in the background. These conical drystone structures were built by monks who retreated to this rocky outcrop off the Kerry coast possibly as early as the sixth century.

Summer on Skellig
Michael: visiting puffins
pose for the camera.

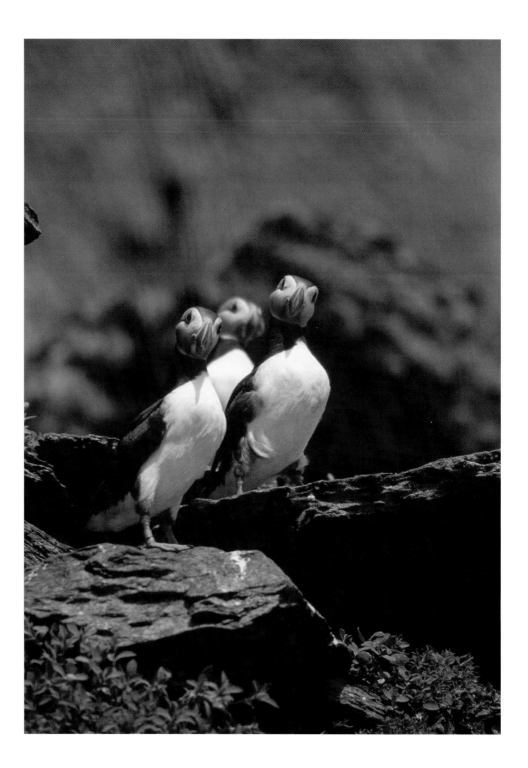

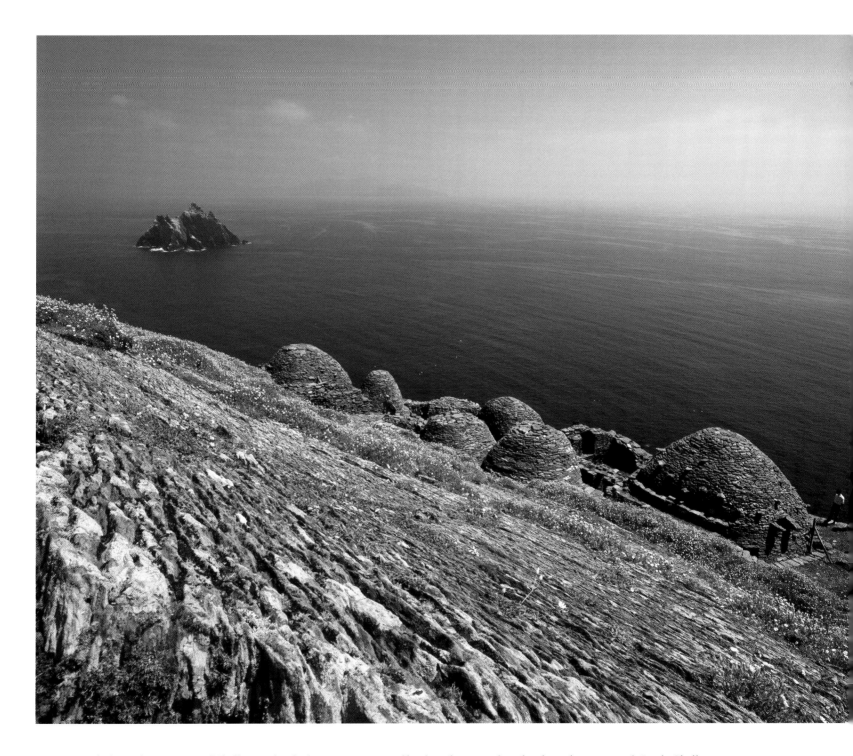

Facing south from the summit of Skellig Michael, the entire group of beehive huts on the island can be seen, with Little Skellig and the vast Atlantic as a backdrop.

Skellig Michael and
Little Skellig from the
air with the Iveragh
Peninsula in the
far distance.

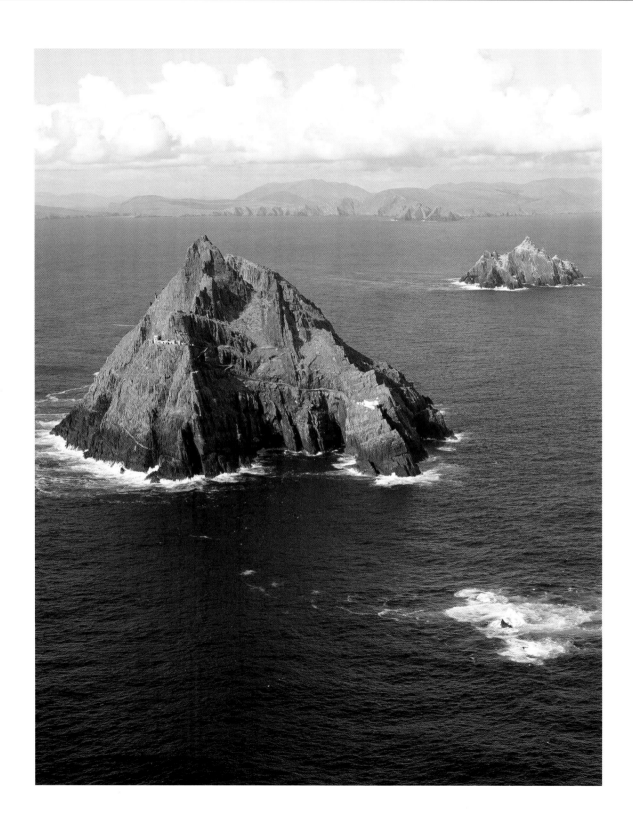

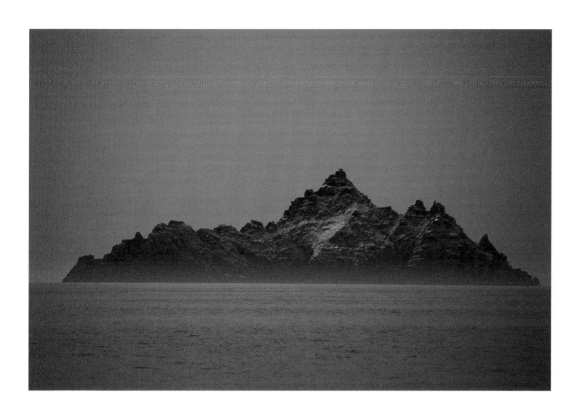

◆ Little Skellig sits in the wide Atlantic in the early morning fog.

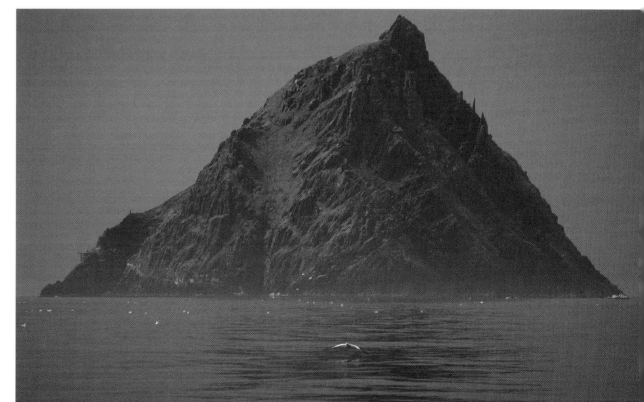

Skellig Michael rises out of the Atlantic, fringed by an early morning mist. ➤

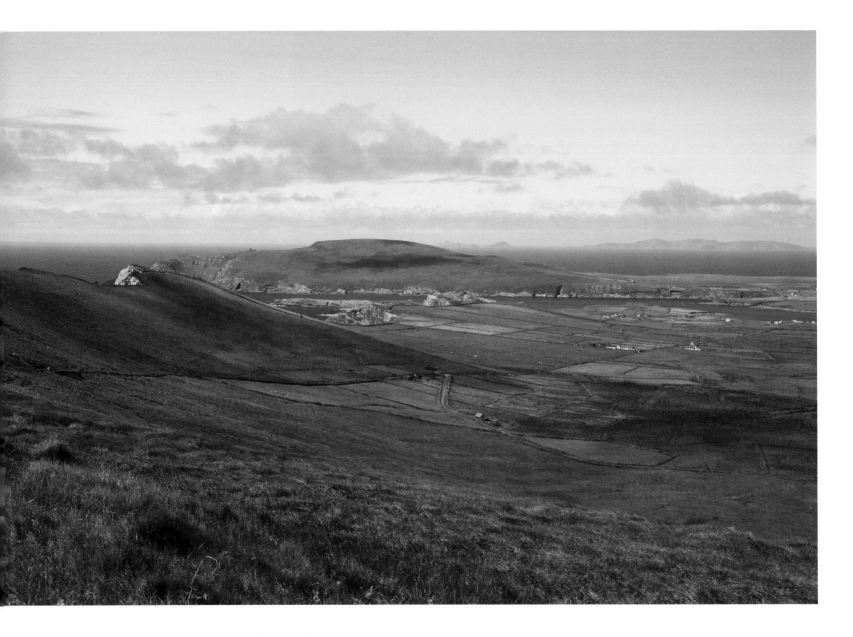

Valentia Island with the Blasket Islands in the distance.

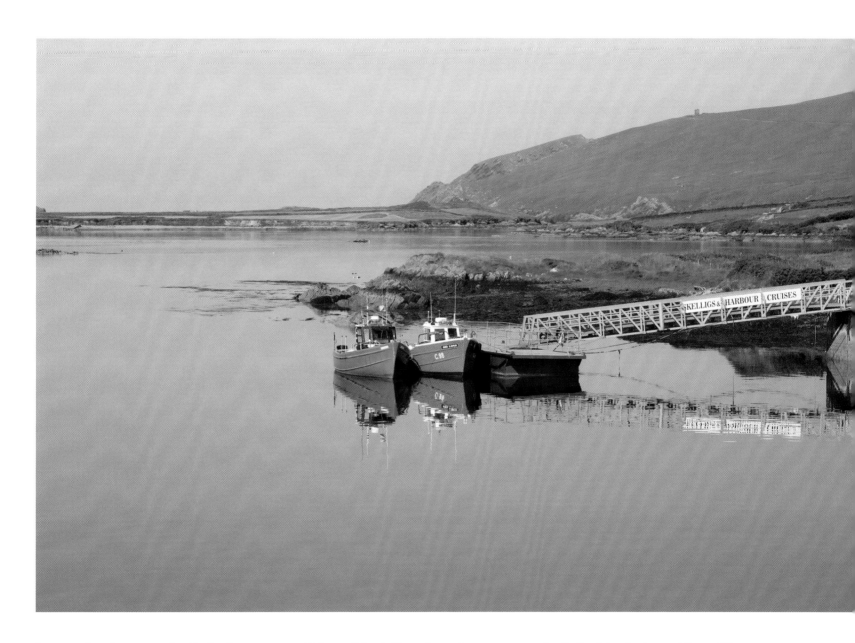

Boats tied to the jetty at the Skellig Experience on Valentia Island. These boats ferry visitors to the Skellig Islands almost 12km offshore.

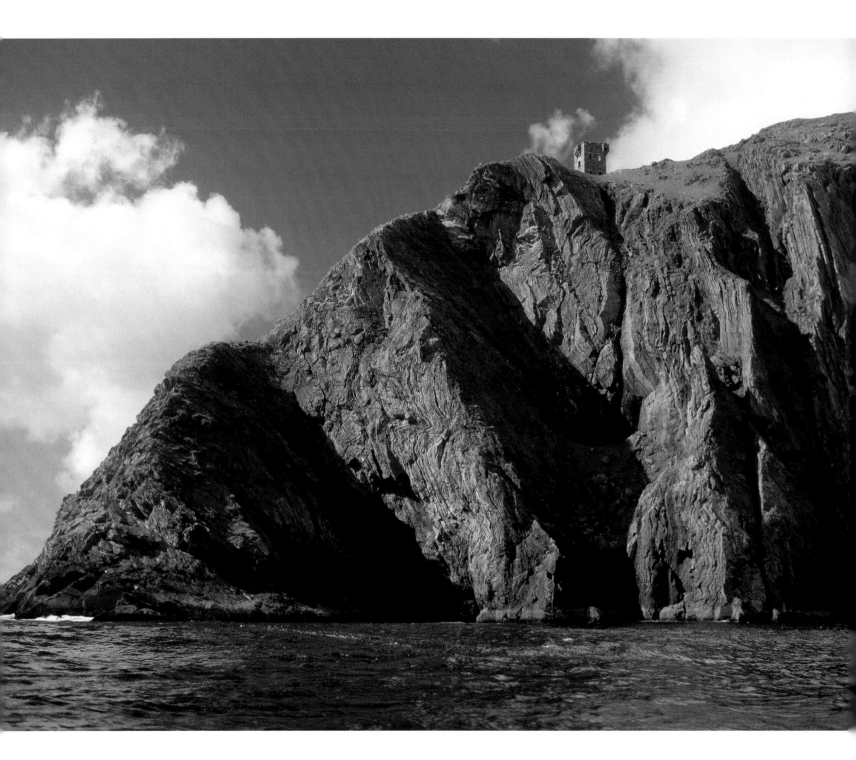

Bray Head on Valentia Island with a lookout tower at the top of the cliff.

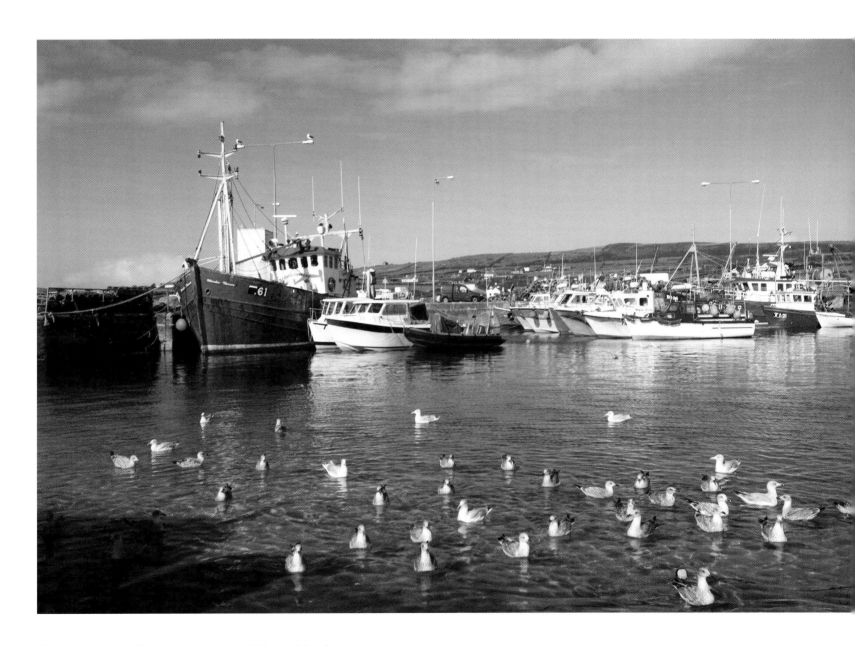

Fishing trawlers at Portmagee, opposite Valentia Island.

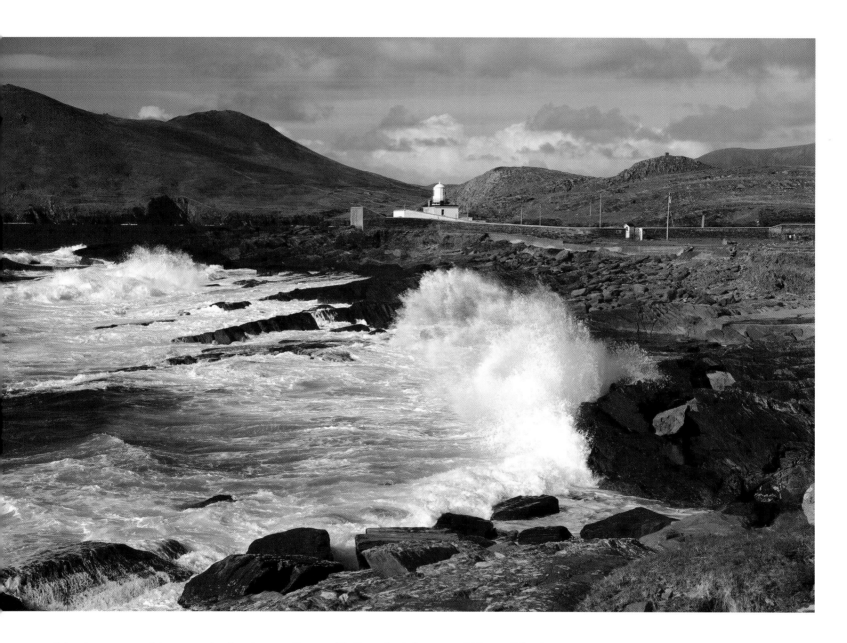

Atlantic waves crashing onto the foreshore at Cromwell's Point Lighthouse on Valentia Island.

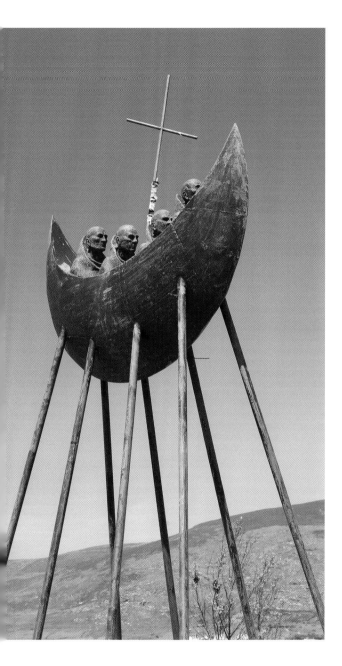

A ruined church near Cahersiveen. ➤

◆ A roadside sculpture at Cahersiveen depicting the voyage of Brendan the Navigator, who is reputed to have reached the New World.

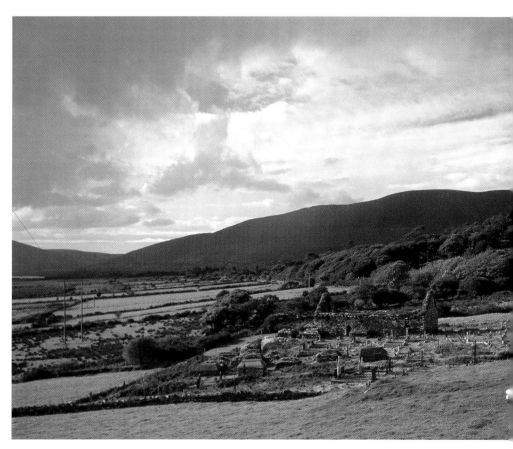

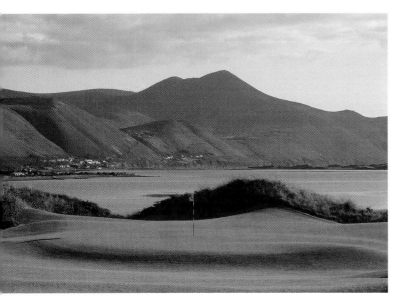

Dooks Golf Links overlooking Dingle Bay.

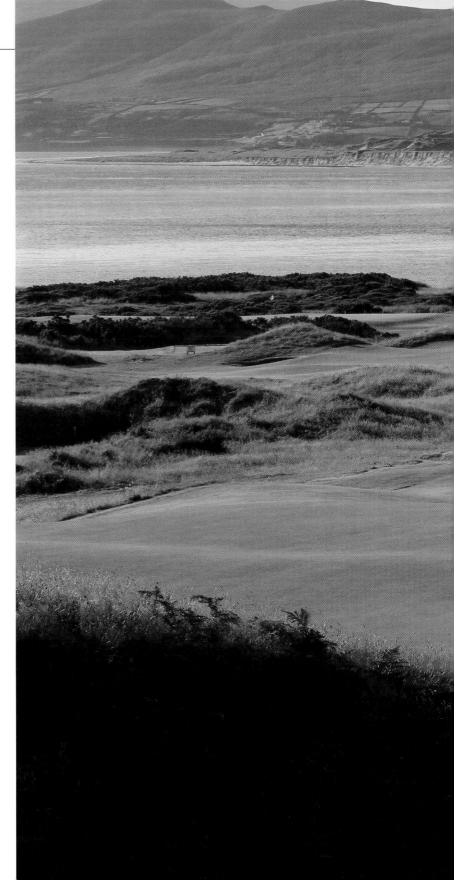

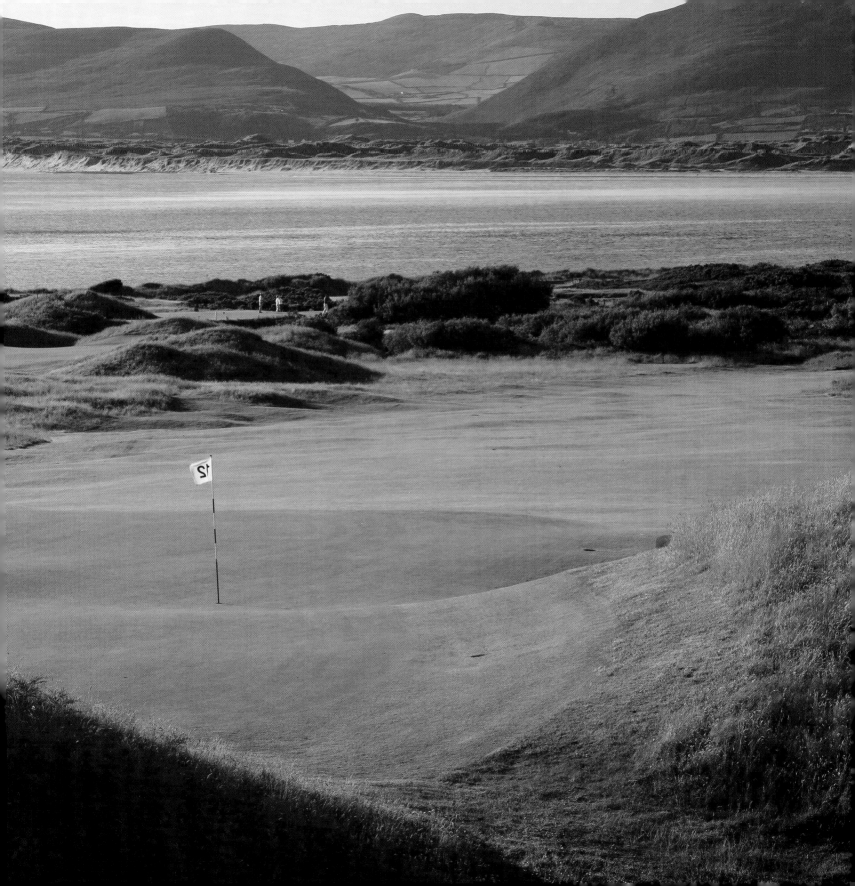

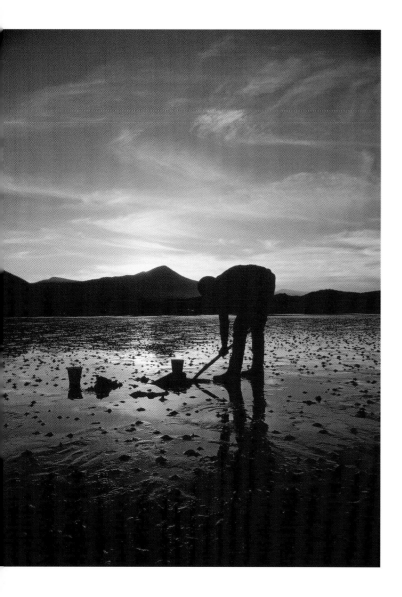

Evening at Rossbeigh: a young angler digs for bait.

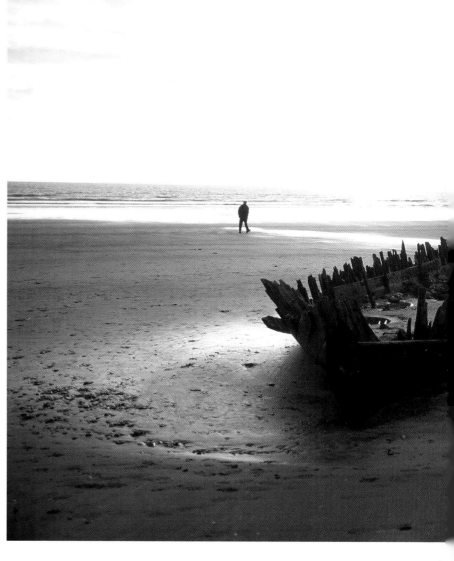

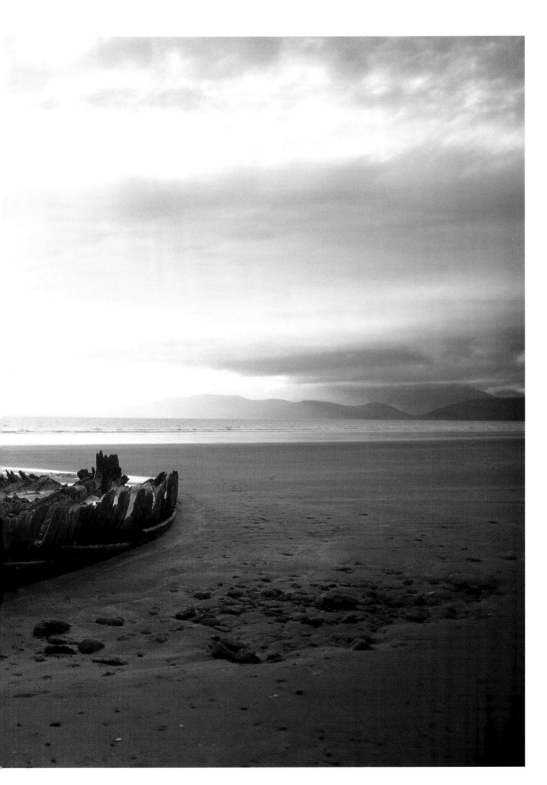

Rossbeigh Beach on Dingle Bay with the remains of a clipper named the *Sunbeam*, which foundered here in 1903.

An angler at dawn on the River Laune near Beaufort.

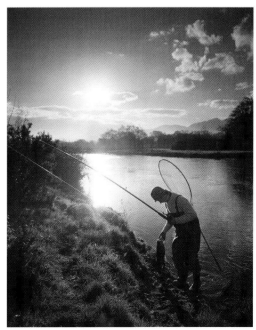

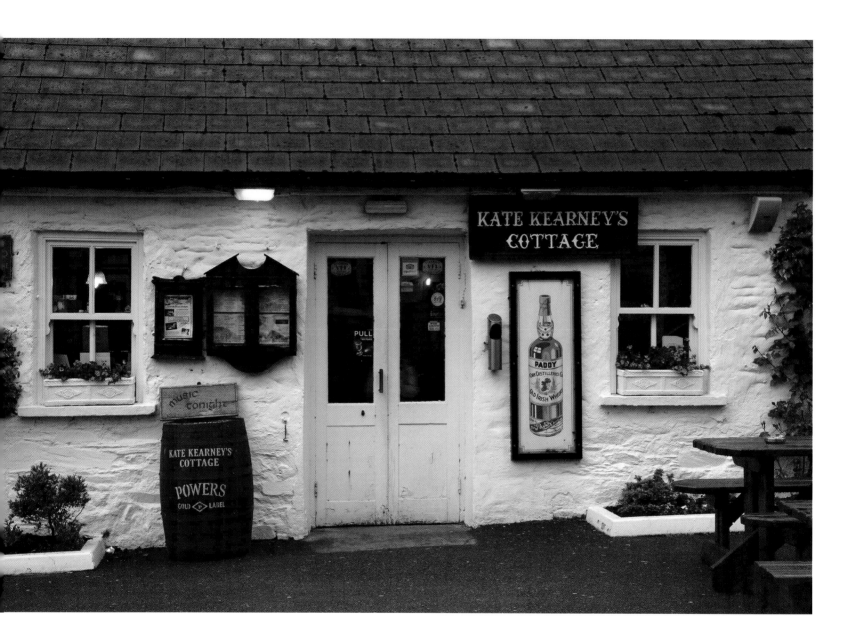

Kate Kearney's Cottage, a popular hostelry at the entrance to the Gap of Dunloe and the mountains beyond.

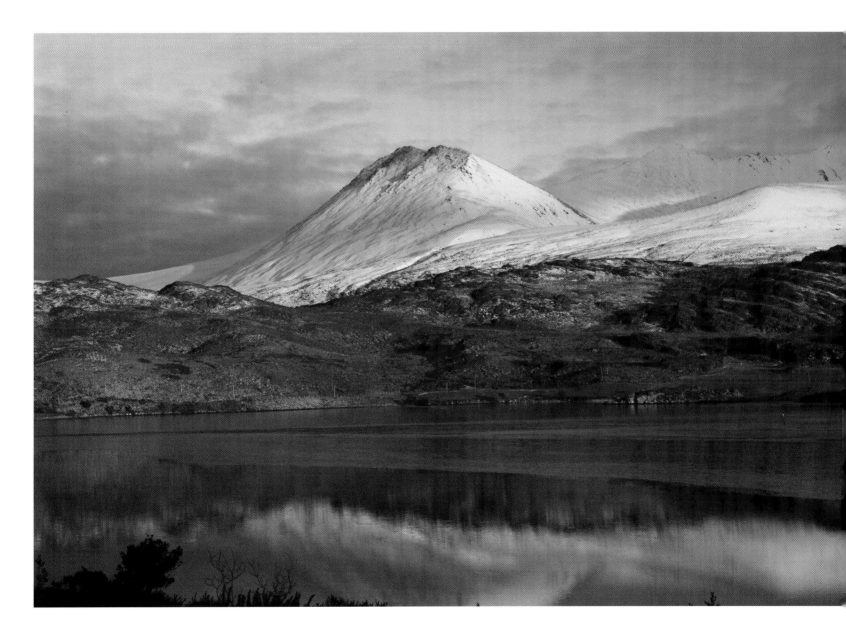

At Glencar, Skregmore and part of the MacGillycuddy's Reeks covered in winter snow reflected in the calm waters of Lough Acoose.

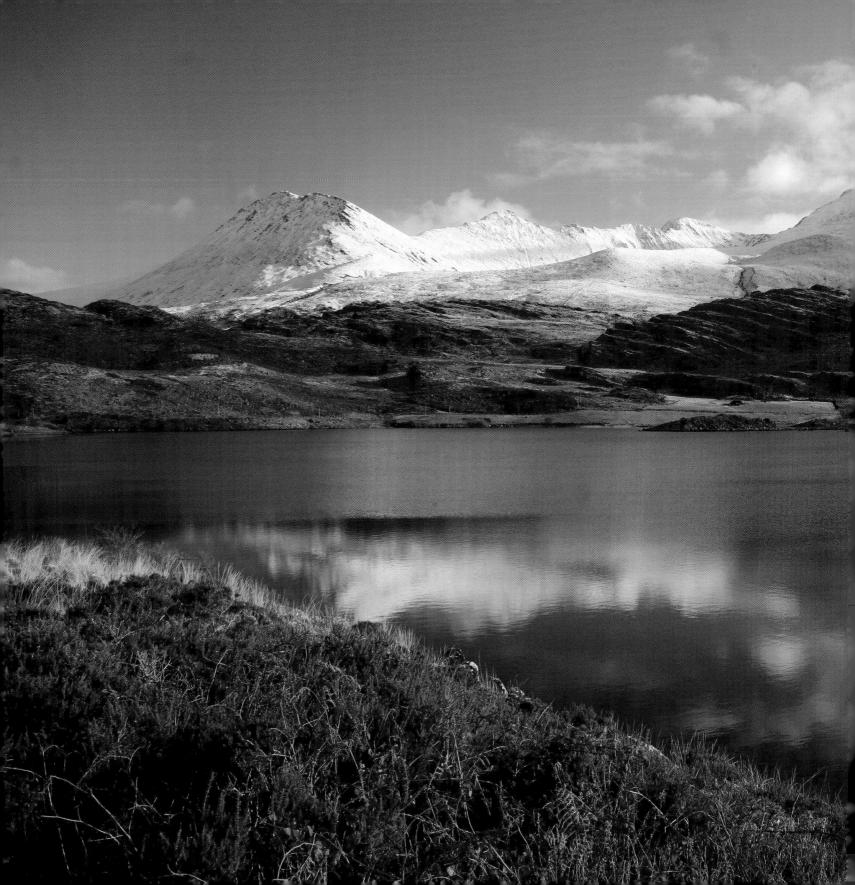

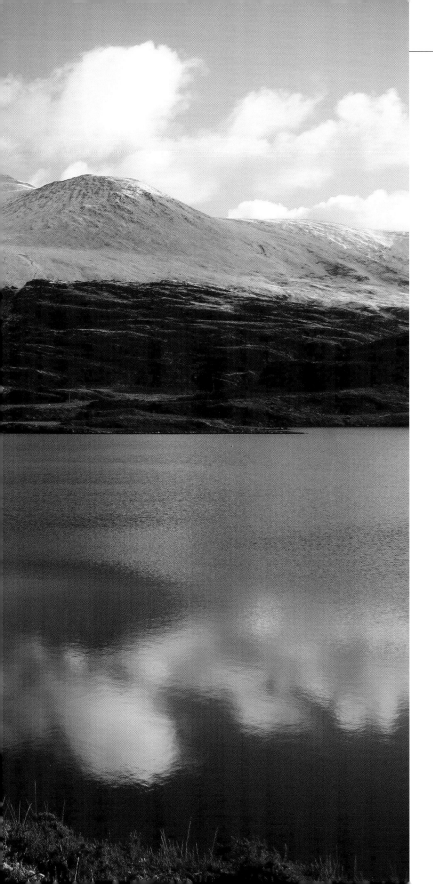

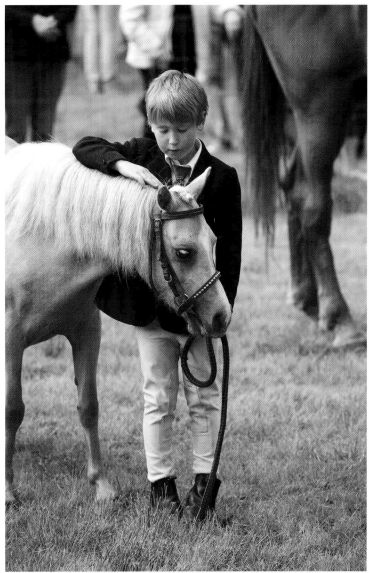

▲ At the annual Glencar Show, an enthusiastic young pony owner examines his prized possession.

◆ Lough Acoose and the MacGillycuddy's Reeks in winter.

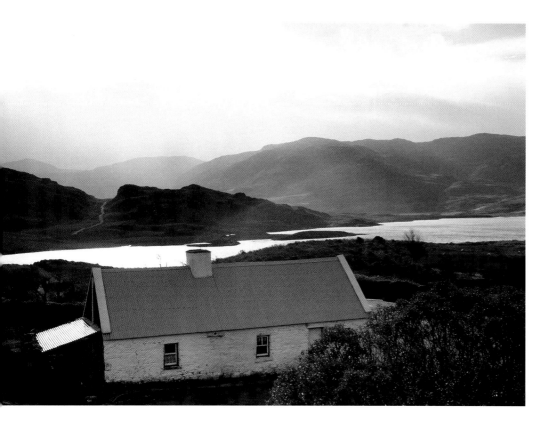

A cottage with a corrugated-iron roof sits in the tranquil landscape at Lough Acoose.

Canoeists brave the winter waters in the Caragh River at Blackstones.

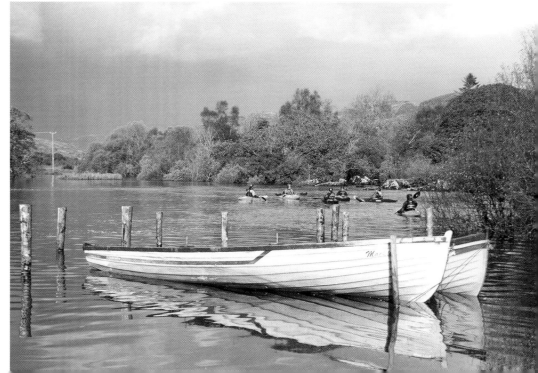

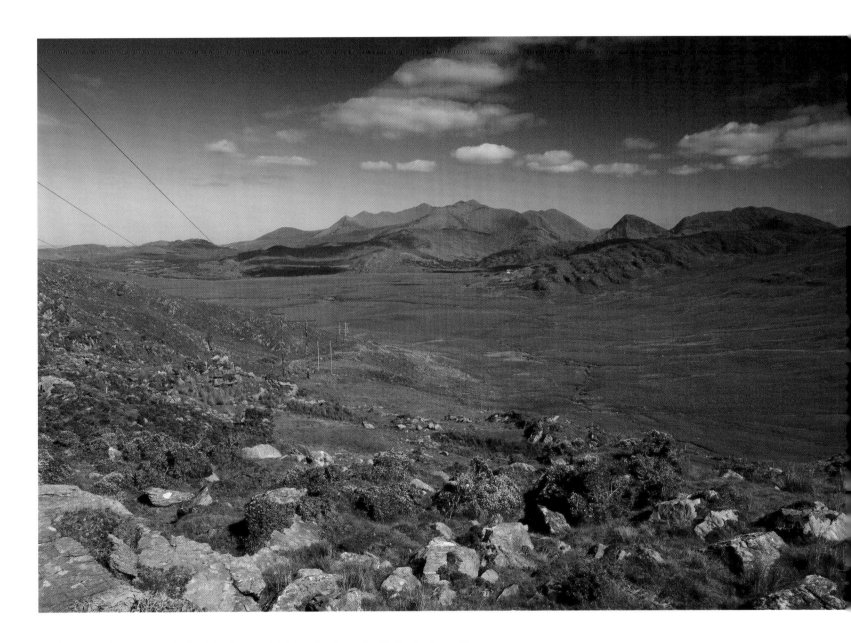

Looking northeast towards the MacGillycuddy's Reeks from the Ballaghasheen Pass.

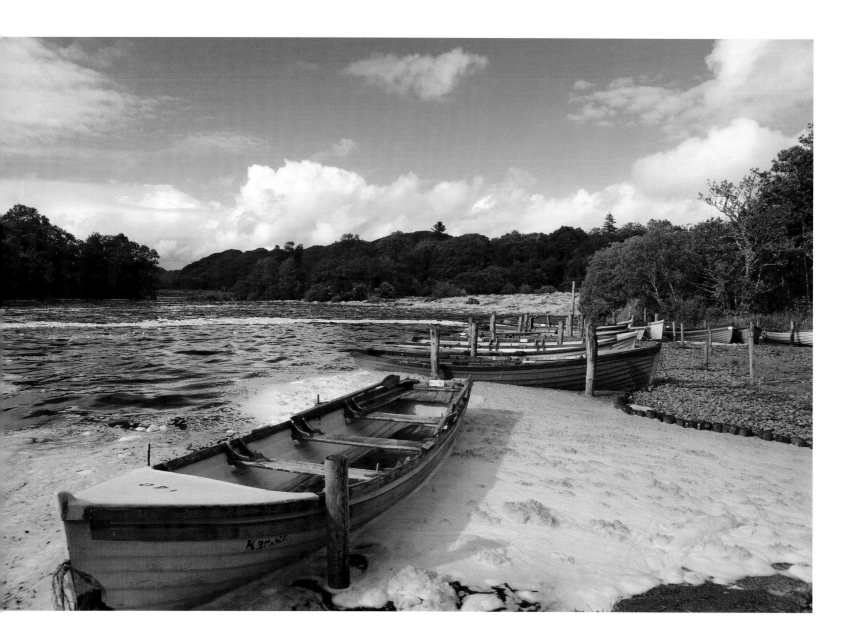

The upper Caragh River in flood after heavy rain near Blackstones Bridge.

Fishing boats on Caragh Lake with the MacGillycuddy's Reeks in the distance.

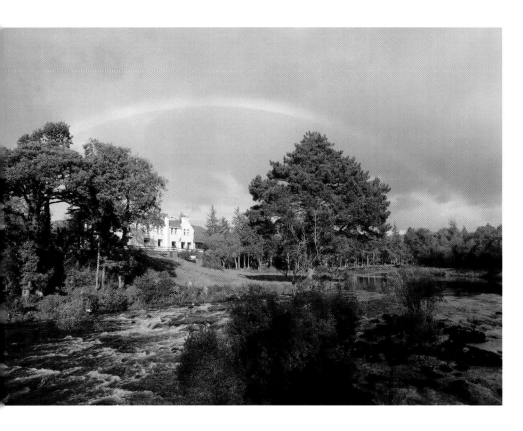

◆ Rainbow over the Caragh River
at Blackstones Bridge.

A country road near Caragh Lake in autumn colours. ➤

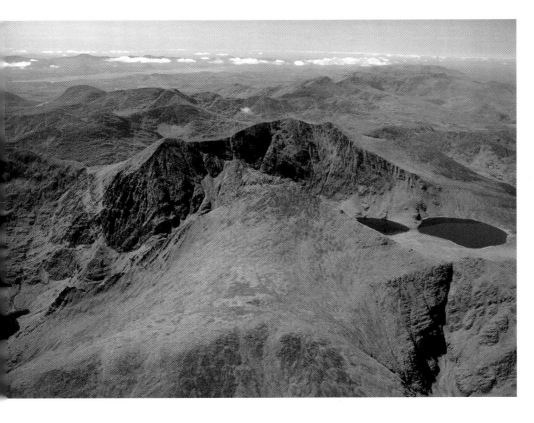

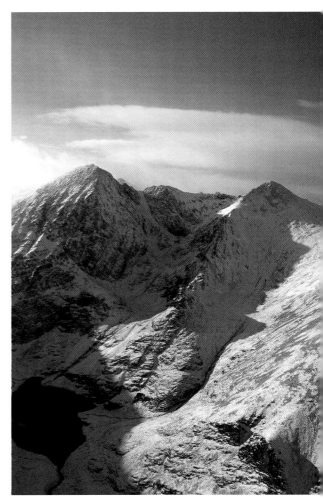

Carrauntoohil, Beenkeragh
and Caher Mountain
with the Kenmare River
in the distance.

The Hags Glen in the MacGillycuddy's Reeks.

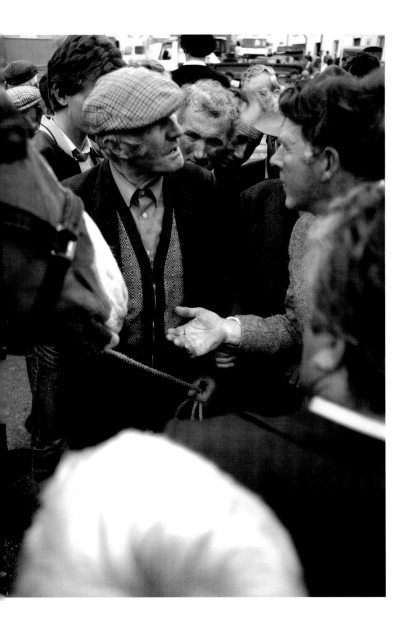

Wheeling and dealing at the annual ♦
Killorglin Puck Fair.

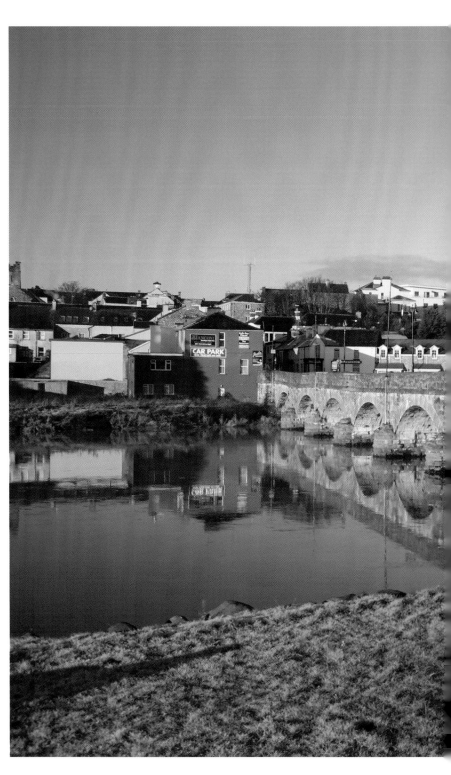

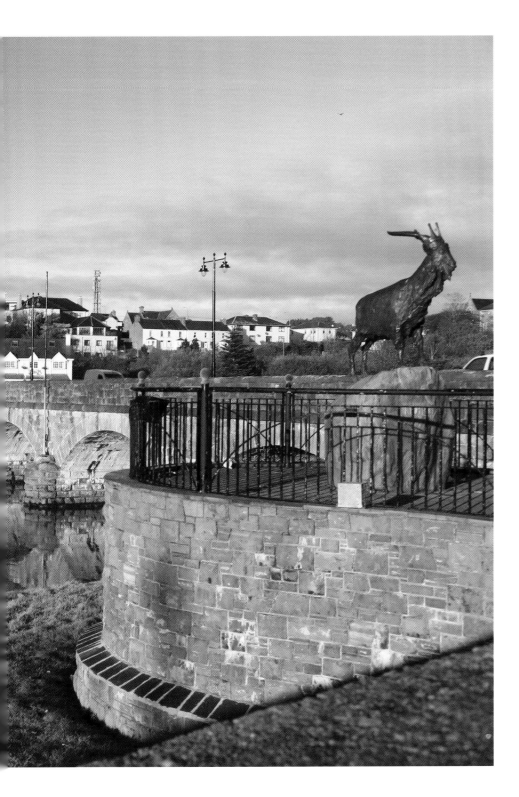

Killorglin on the River Laune.
The sculpture of the goat celebrates
the annual Puck Fair held
every August.

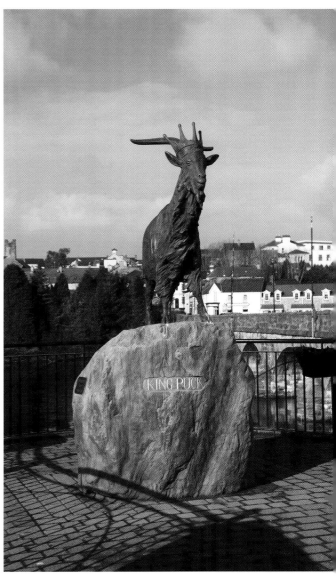

The brightly coloured
doors of an old bakery
in Killorglin.

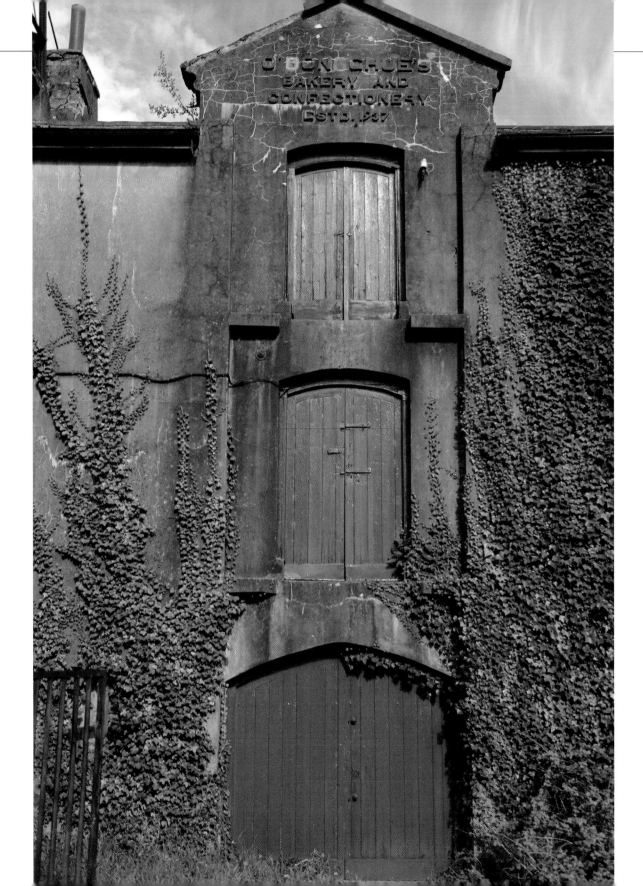

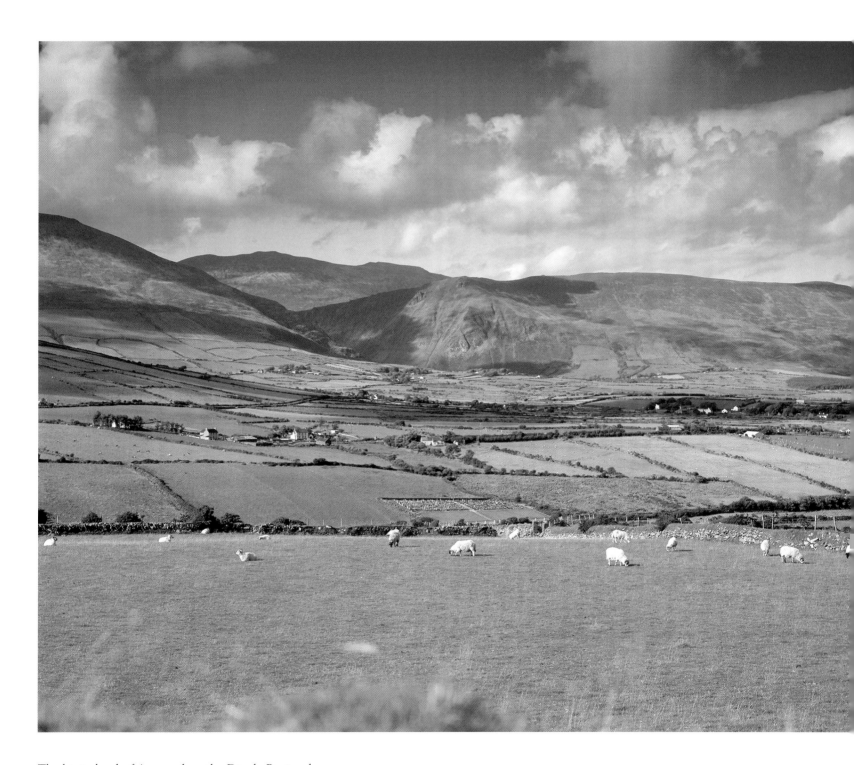

The hinterland of Anascaul on the Dingle Peninsula.

A brightly painted
hairdresser's in
Anascaul village.

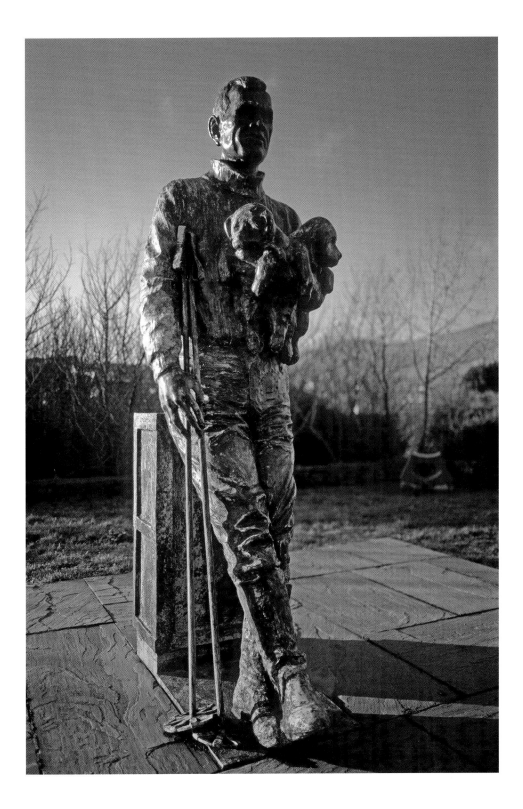

The sculpture in Anascaul
of Tom Crean (1877–1938),
the Antarctic explorer.

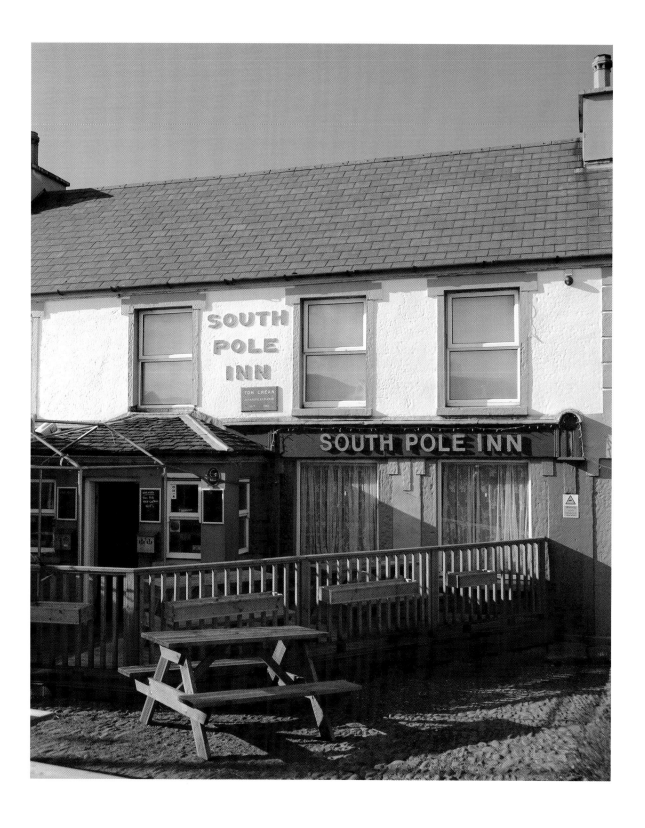

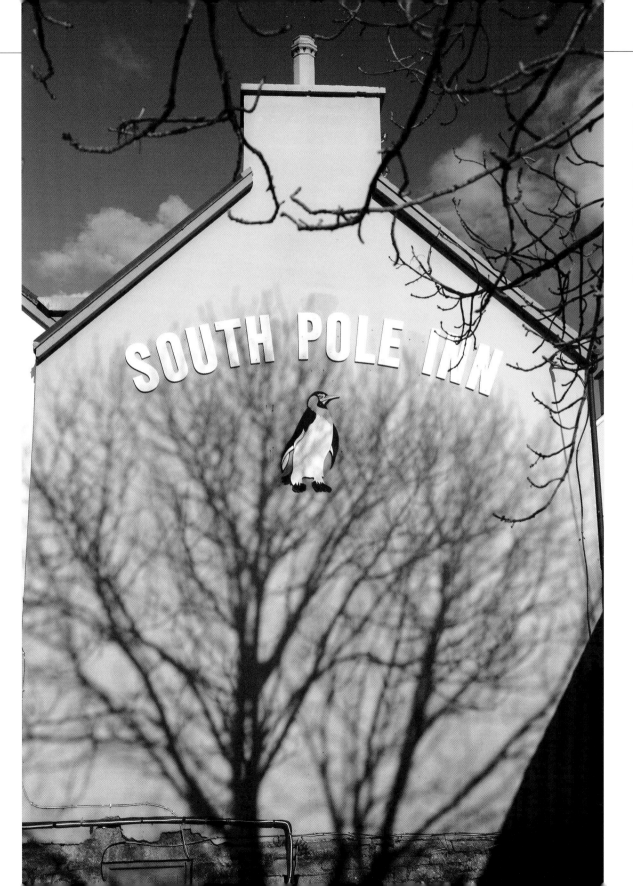

The South Pole Inn in Anascaul was opened in 1920 by Tom Crean after his final return from the Antarctic. Anascaul is famous as the birthplace of Tom Crean, who travelled to the Antarctic with both Robert Scott and Ernest Shackleton.

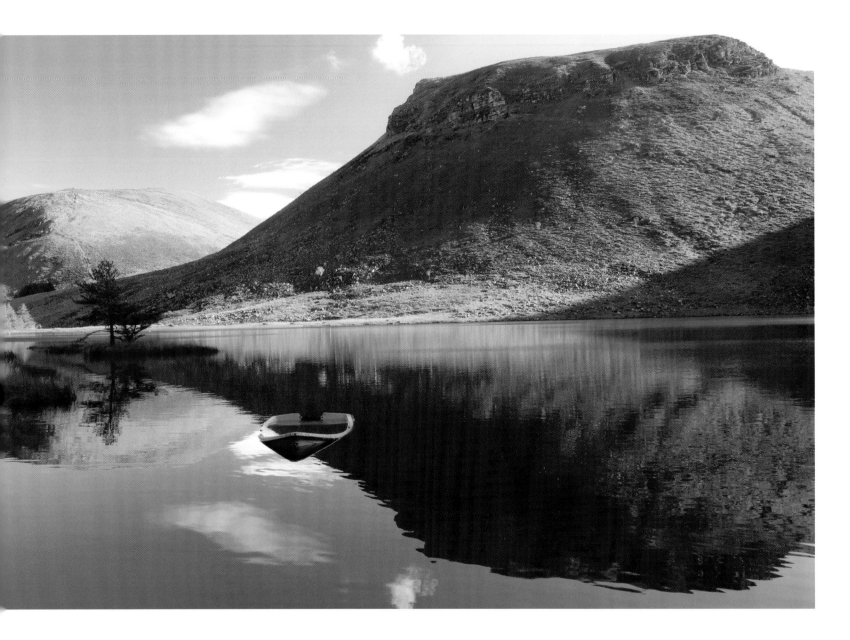

The splendid solitude of Lough Caum in Glanteenassig Forest Park.

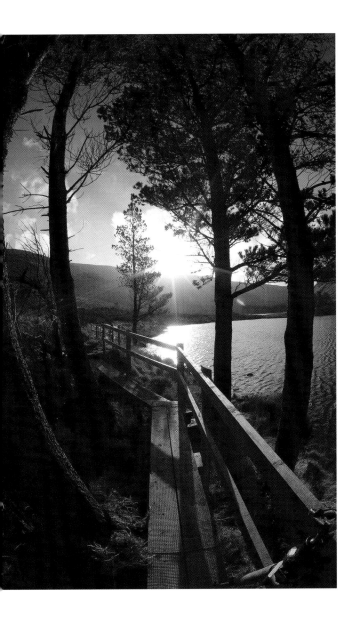

◄ A walkway at Glanteenassig Lake.

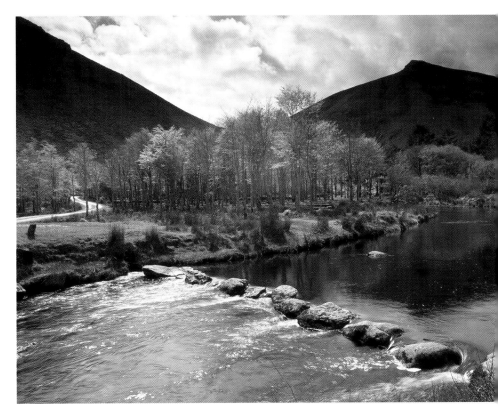

Stepping stones across a river ➤
in Glanteenassig Forest Park.

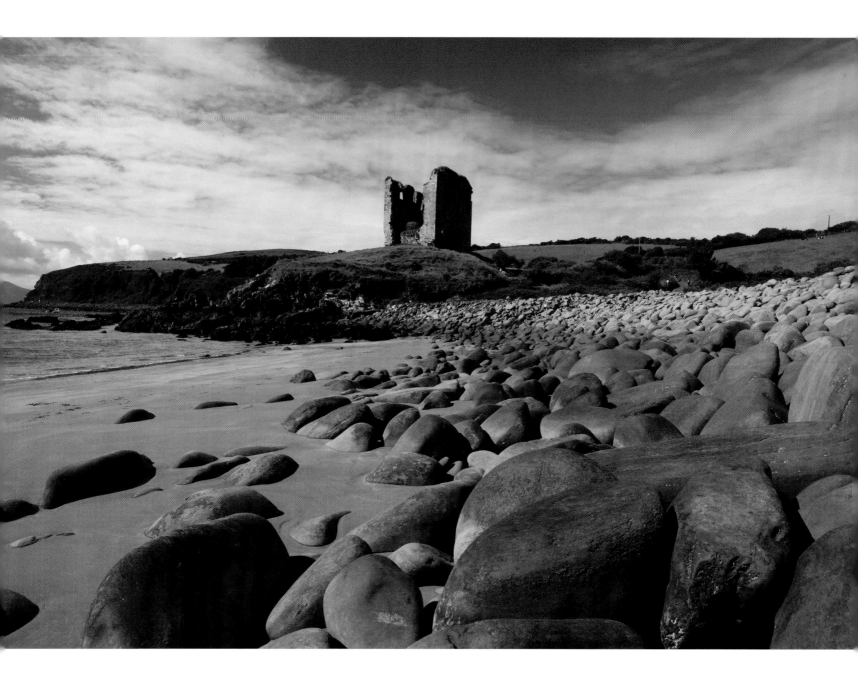

Sixteenth-century Minard Castle overlooks Dingle Bay. It was from here in 1892 that Tom Crean set off on his travels at the age of fifteen.

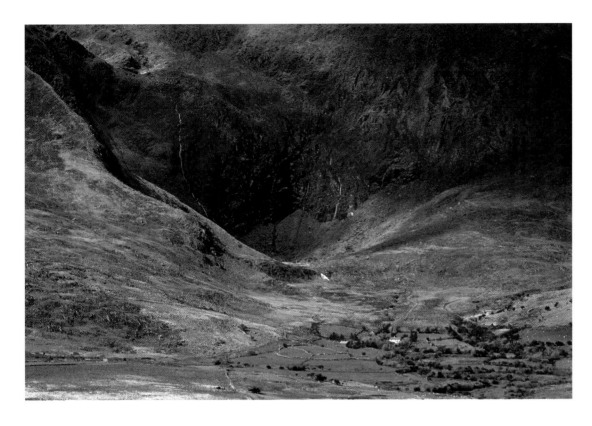

Looking towards the Lough Avoonane cliffs from the Owenmore Valley.

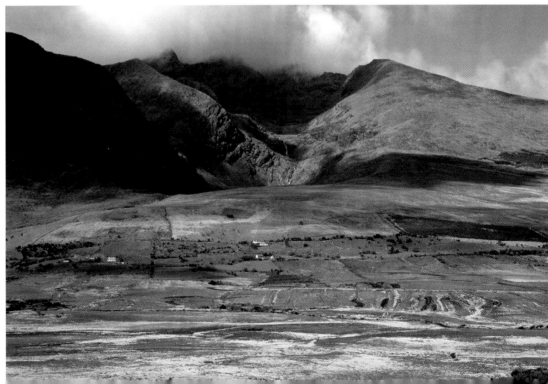

Looking towards Glanshanacuirp and Mount Brandon across the Owenmore Valley.

Dick Mack's is one
of Dingle's better-known
pubs, with the bar on
one side and goods
on the other.

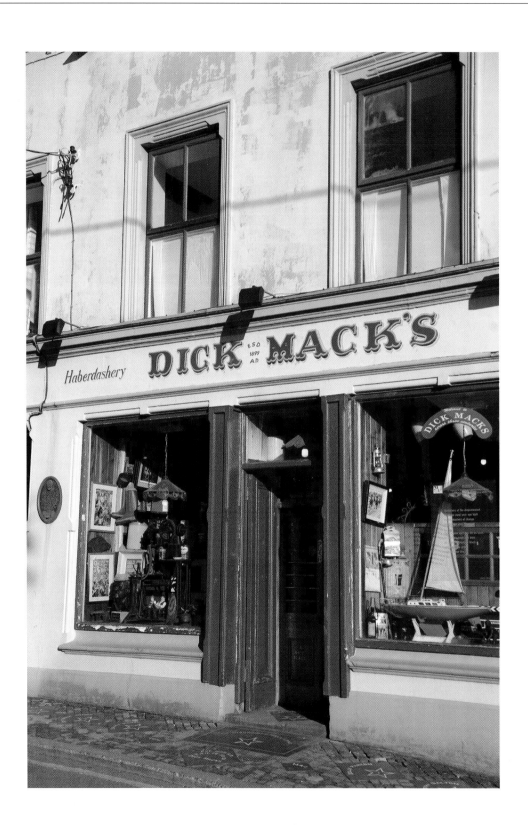

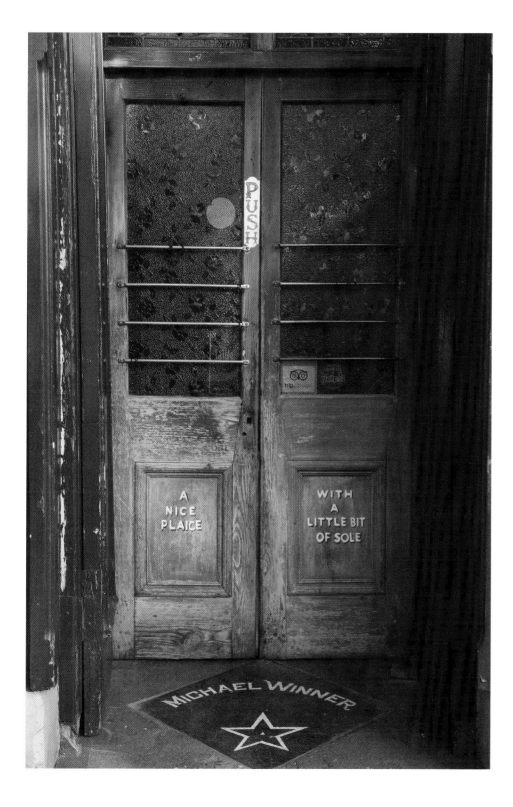

The entrance door to Dick Mack's. The flagstone commemorates one of the pub's more famous customers.

An improvised door lock.

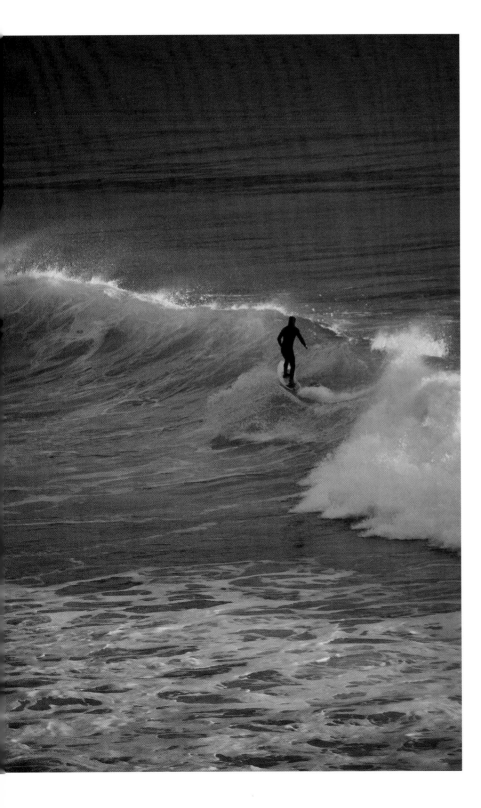

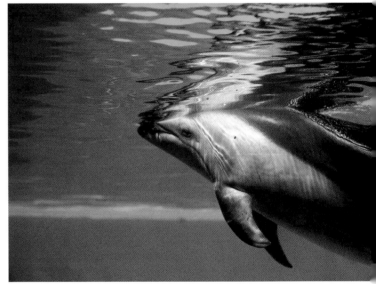

◆ Surfing the Atlantic waves off the Dingle Peninsula.

◆ Funghi, Ireland's most famous dolphin, who has lived in Dingle Bay for over forty years.

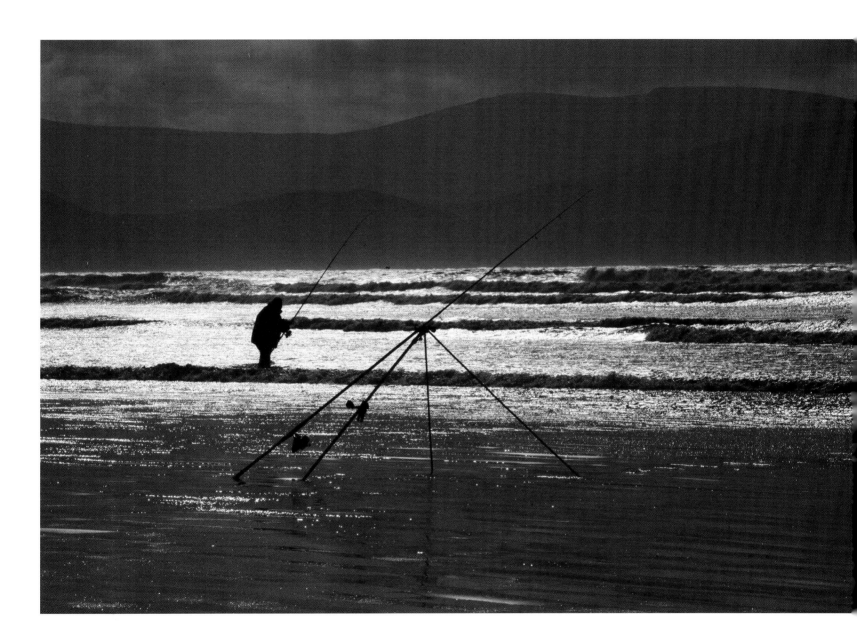

Inch Beach: sea angling in the rough Atlantic seas of Dingle Bay.

Dingle's colourful waterfront.

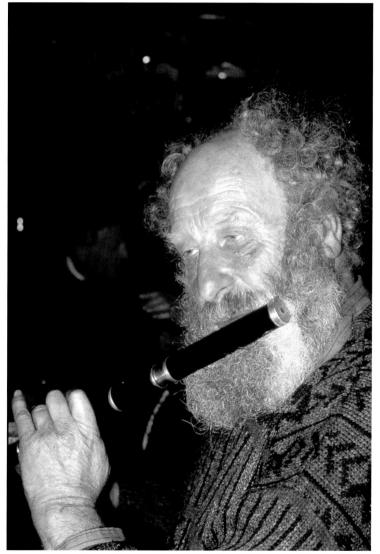

A colourful stack of fish boxes.

A traditional Irish musician in a Dingle pub. ➤

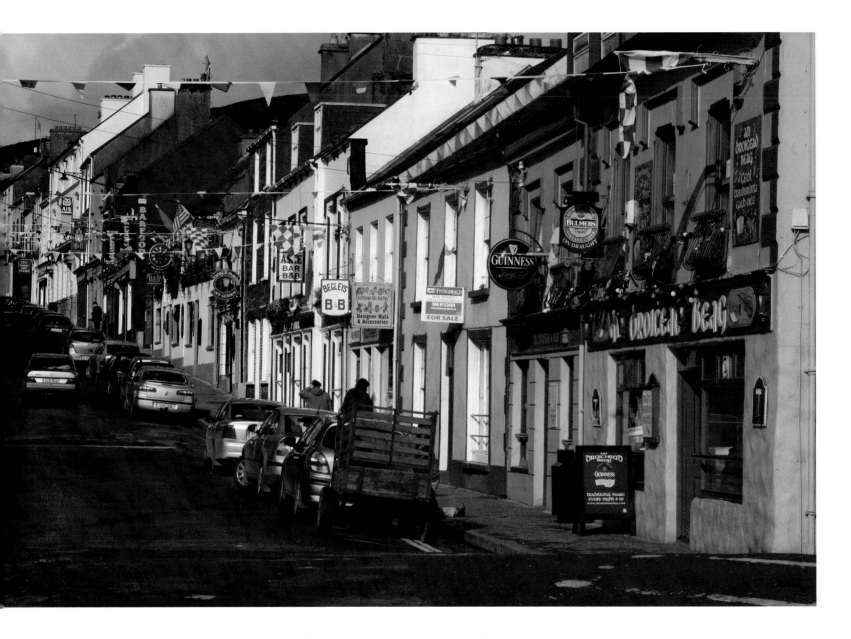

🔺 Main Street in Dingle town, a busy tourist destination with its restaurants and pubs.

➡ The graceful curve of Inch Strand on the Dingle Peninsula. This was one of the locations used for a film of J. M. Synge's *The Playboy of the Western World* and David Lean's film *Ryan's Daughter*.

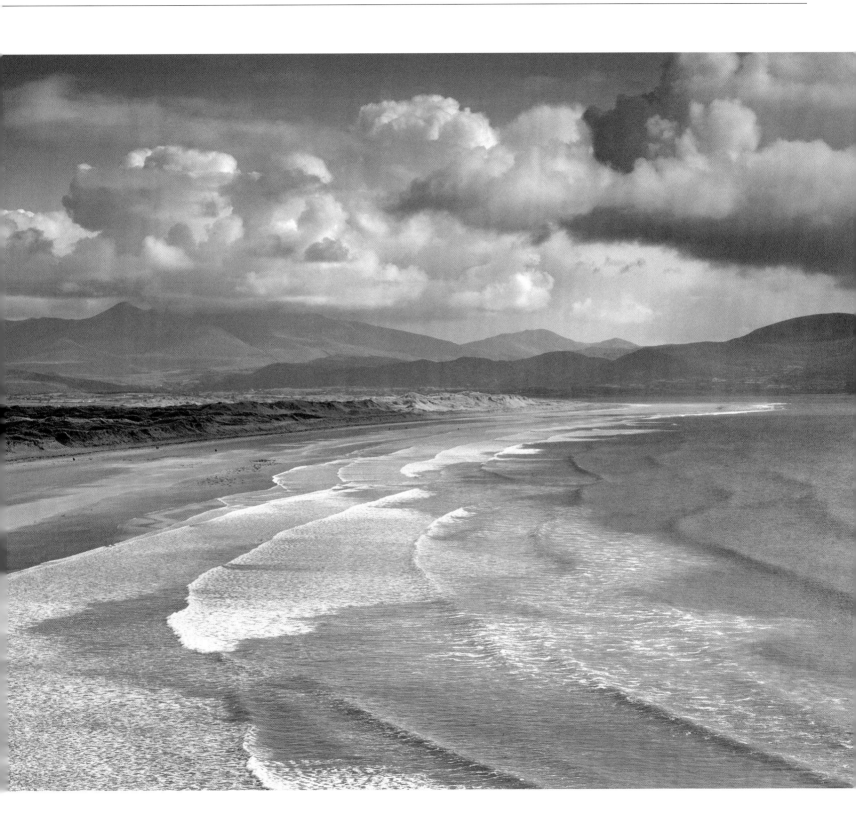

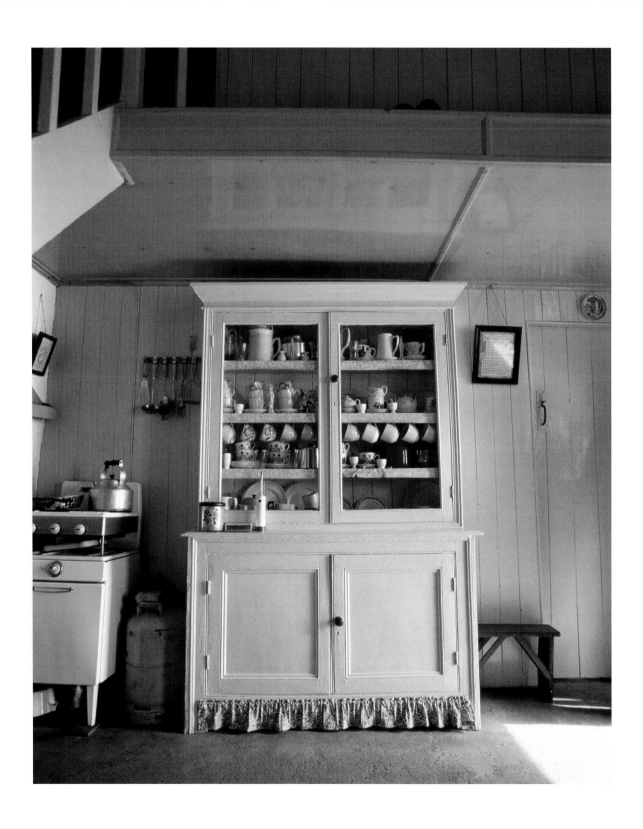

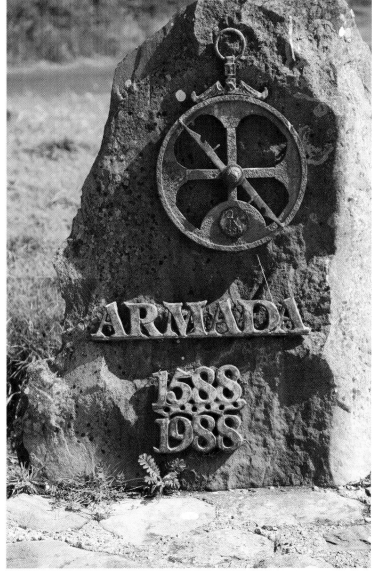

This monument marks 400 years since the sinking of two ships of the Spanish Armada off Dunmore Head in a storm in 1588.

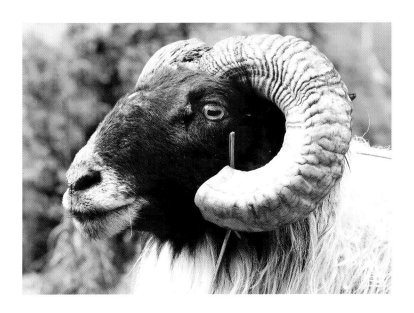

The sheep's curved horns have been cut to prevent them growing into the side of its head.

A traditional kitchen dresser in a house on Slea Head.

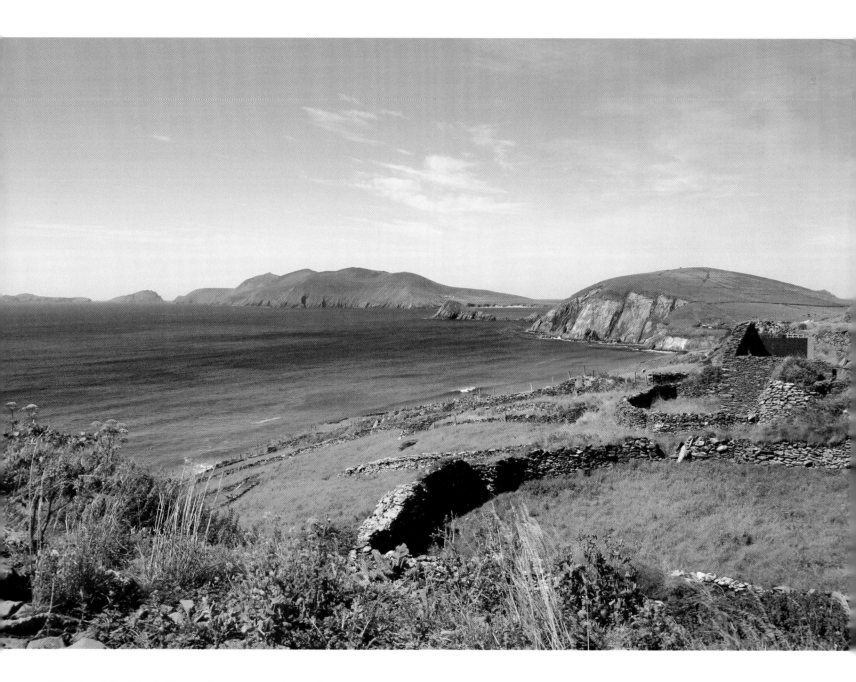

The tip of the Dingle Peninsula in a tranquil mood.

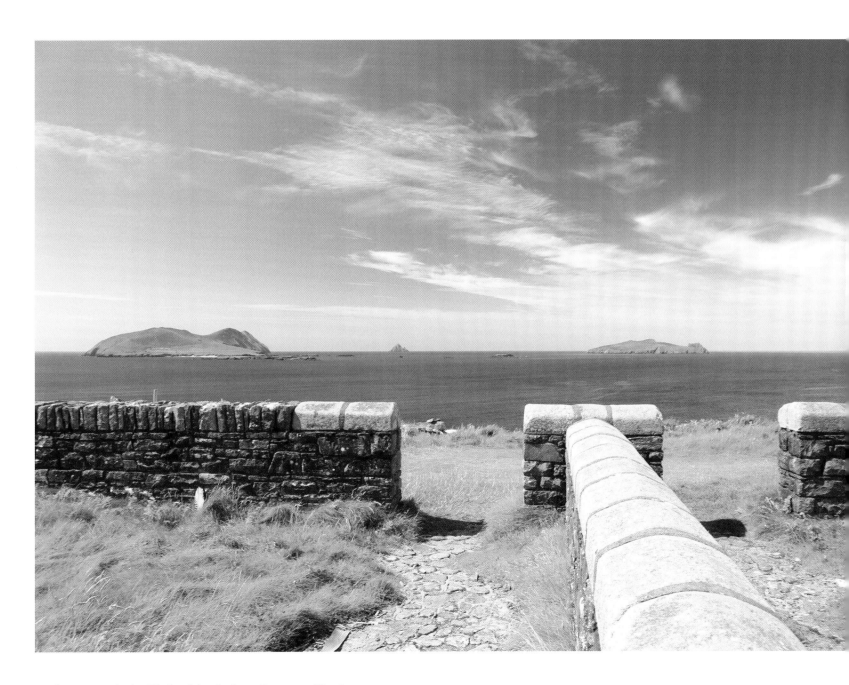

Looking towards the Blasket Islands from Dunmore Head.

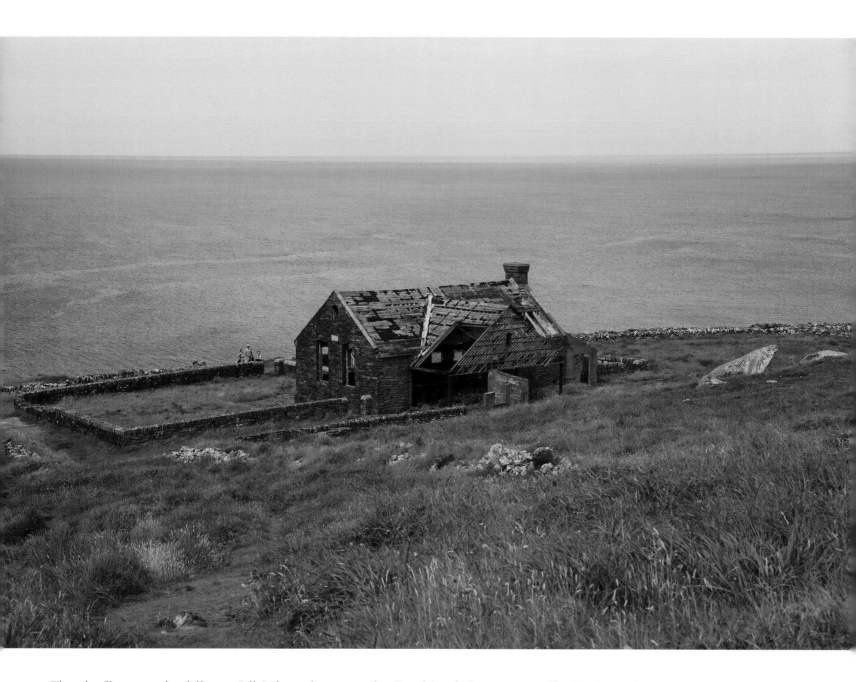

The schoolhouse on the clifftop at Cill Gobnait that was used in David Lean's Oscar-winning film *Ryan's Daughter*.

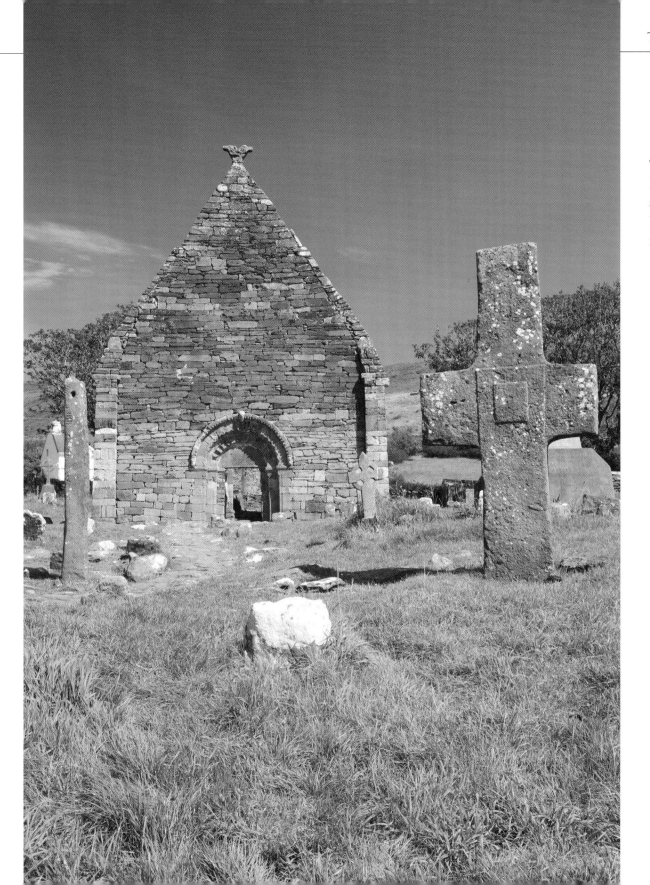

The twelfth-century
Romanesque church
and graveyard at
Kilmalkedar,
near Dingle.

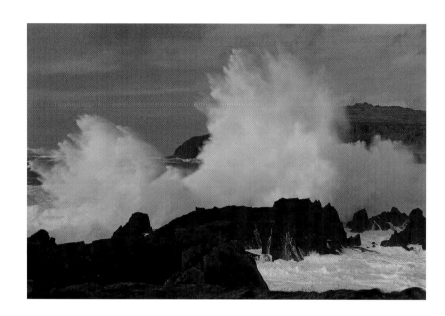

◆ Atlantic waves crash onto the rocky coastline near Sybil Head on the Slea Head Drive.

◆ Gallarus Oratory, dedicated to St Brendan, Kerry's patron saint.

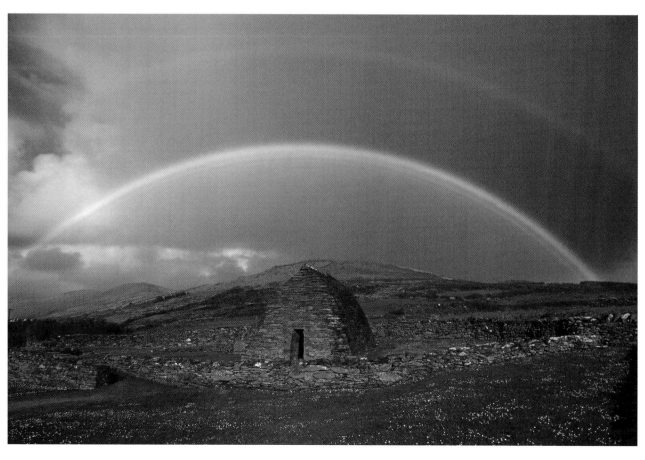

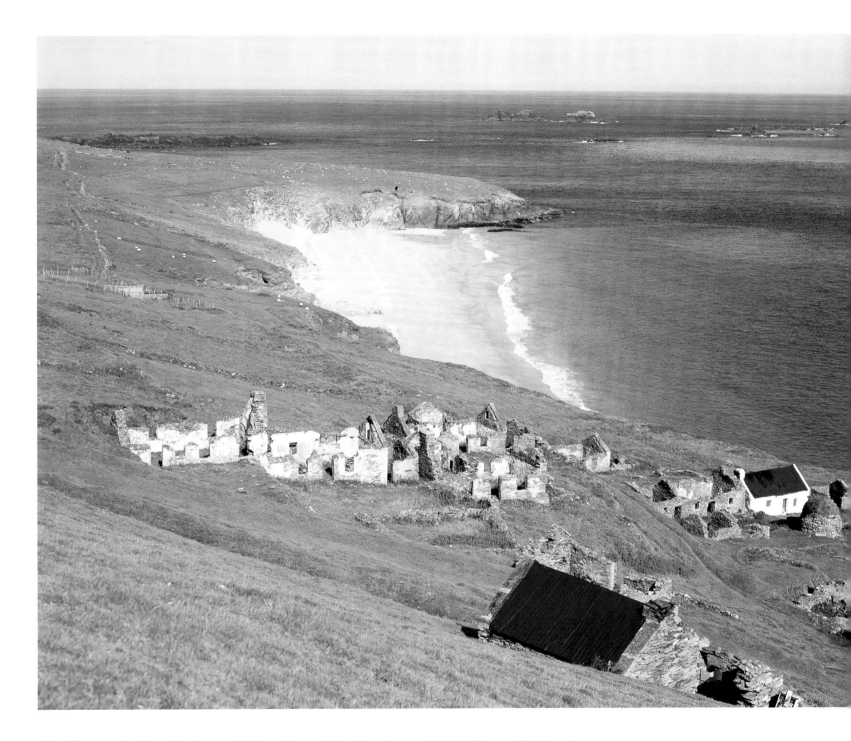

The village on the Great Blasket, overlooking the sandy beach and open Atlantic. Next parish: America.

The steep descent to Dunquin Pier, from where ferries make regular crossings to the Blasket Islands.

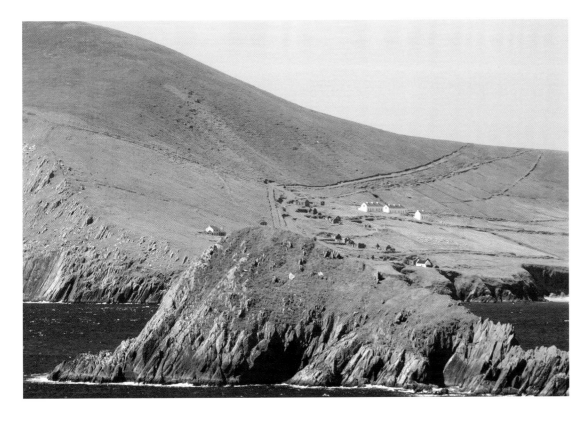

The ruined village of the Great Blasket Island seen from Dunmore Head. A Spanish Armada ship, the *Santa Maria de la Rosa*, foundered at this headland.

Inishtooskert silhouetted in open sea. A steep-sided rocky outcrop, it is the farthest north of the Blasket Islands.

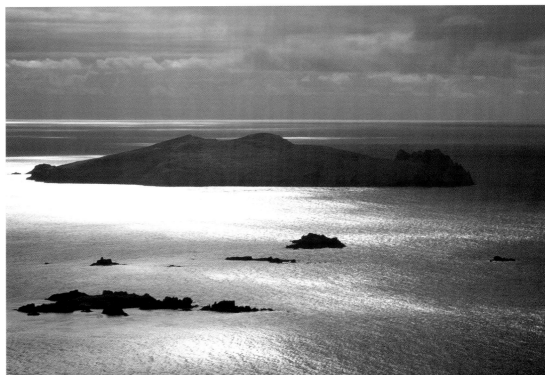

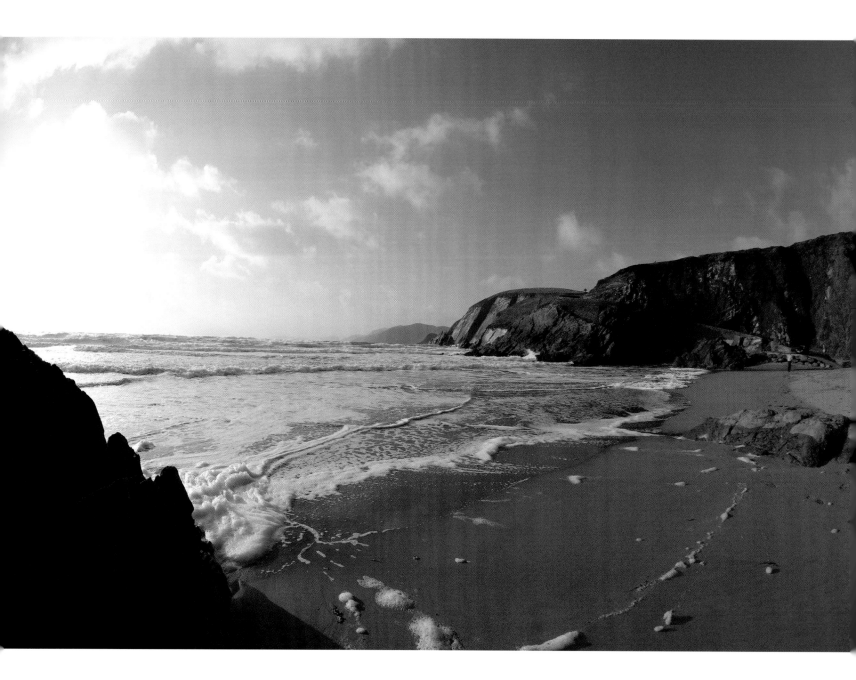

Coumeenole Strand, made famous by David Leane in his film *Ryan's Daughter*, was one of the locations used in another film, *Far and Away* which starred Nicole Kidman and Tom Cruise.

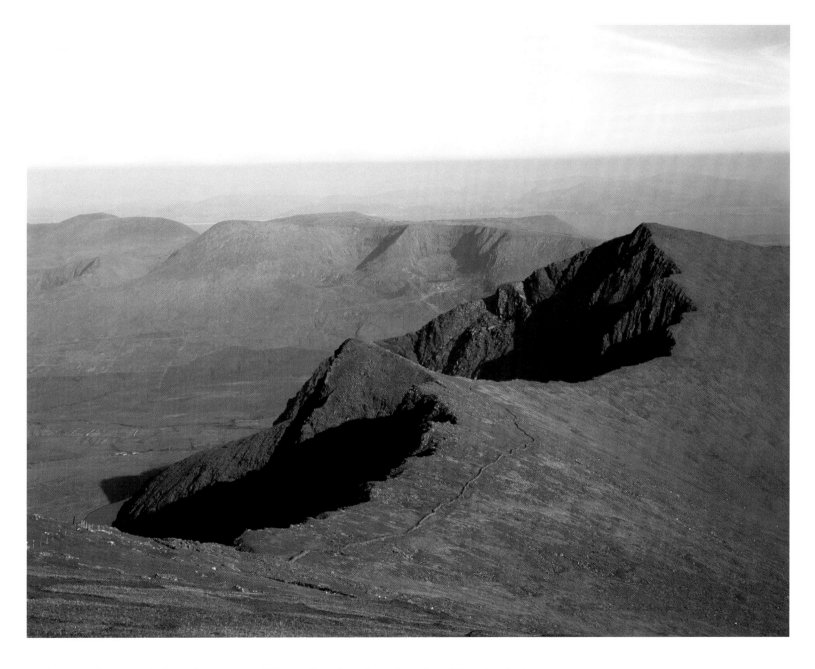

Looking south-eastwards from the summit of Mount Brandon along the ridge of Brandon Peak.

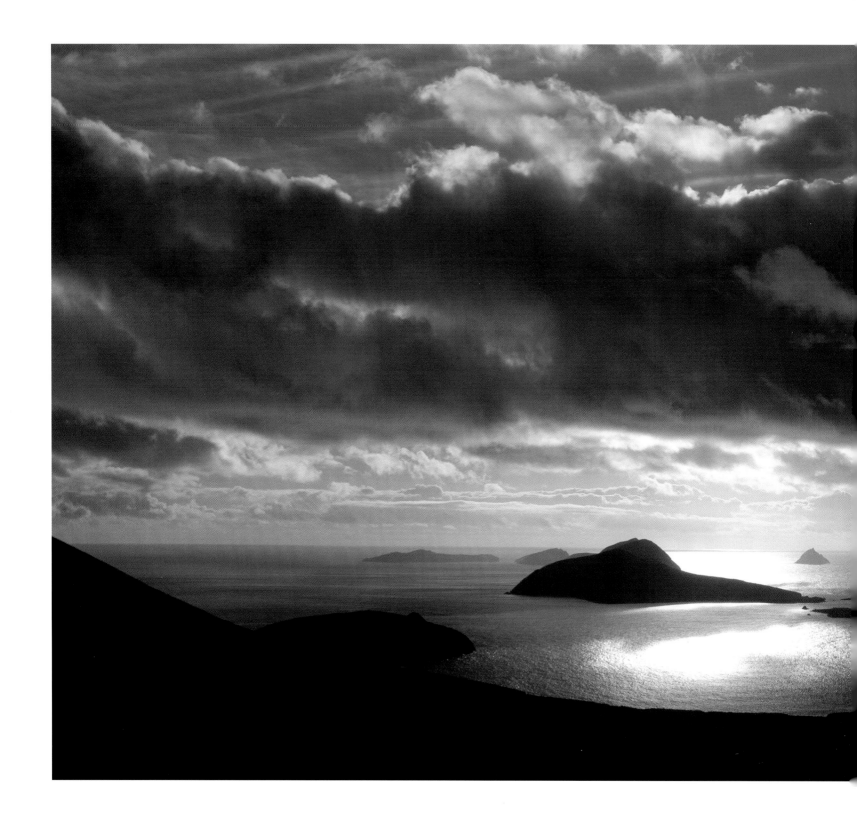

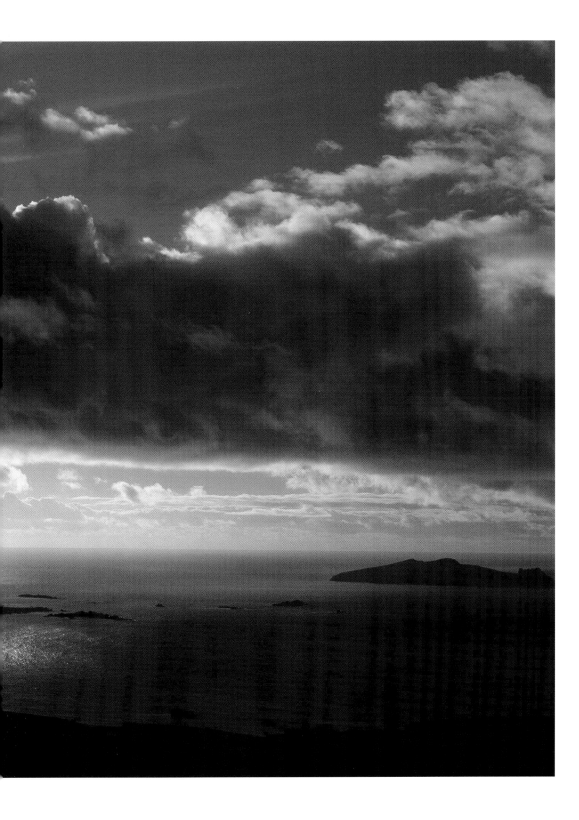

The Blasket Islands in evening mood.
The complete archipelago is visible
in this photograph.

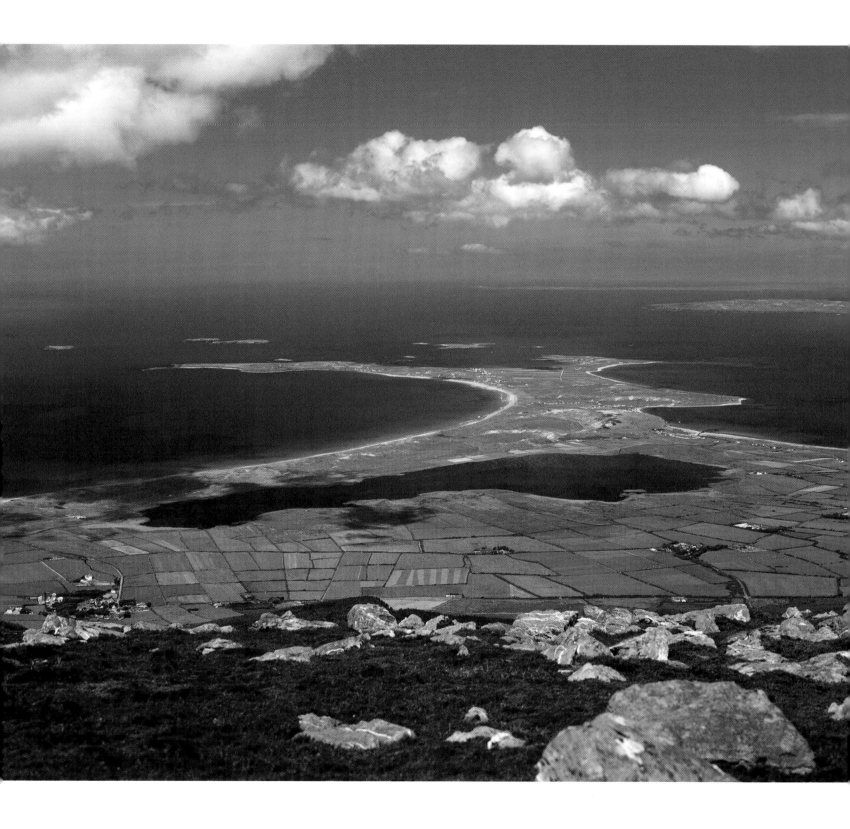

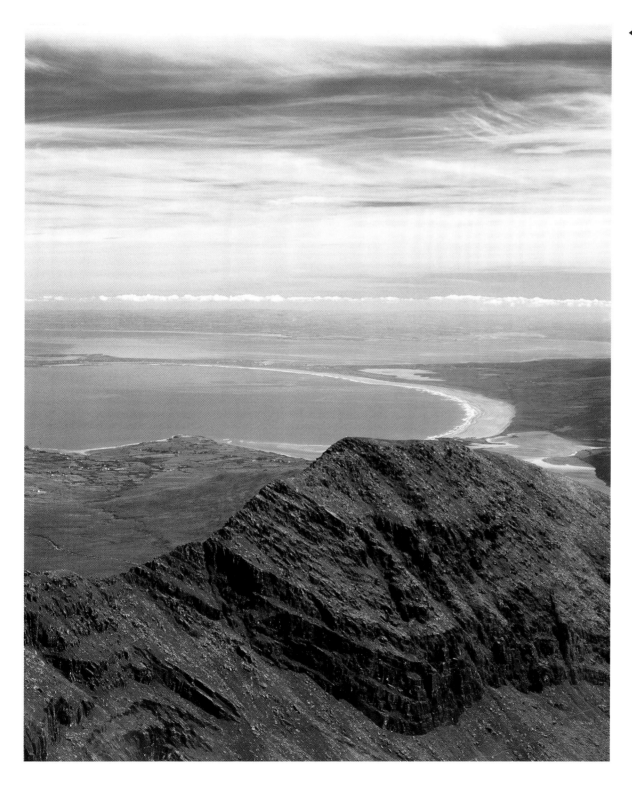

◄◄ The view from the summit of Mount Brandon over Brandon Bay.

◄ The Maharees Peninsula juts out between Tralee Bay and Brandon Bay with the Maharees or Seven Hogs Islands off the end of the peninsula.

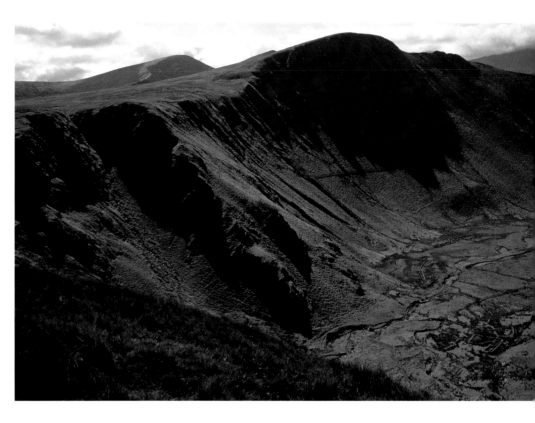

↟ The Maghanaboe Valley near Cloghane once supported a small community, as evidenced by the walled ruins below.

↞ The sea inlet at Fermoyle overlooked by Mount Brandon provides a safe anchorage.

➡ The tidal inlet at Cloghane.

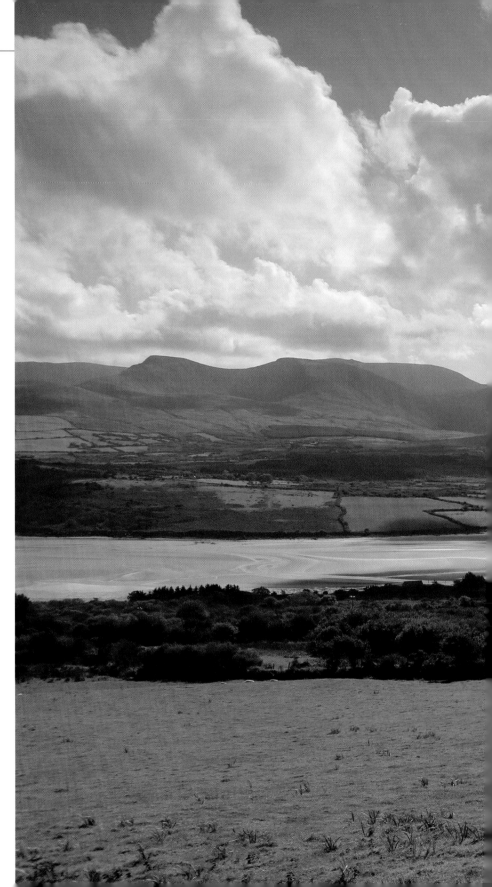

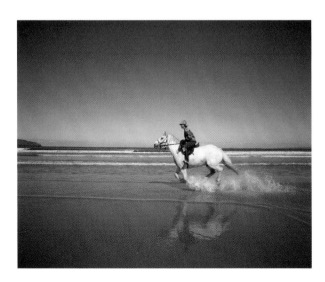

⬆ Horse riding on Brandon Bay,
Dingle Peninsula.

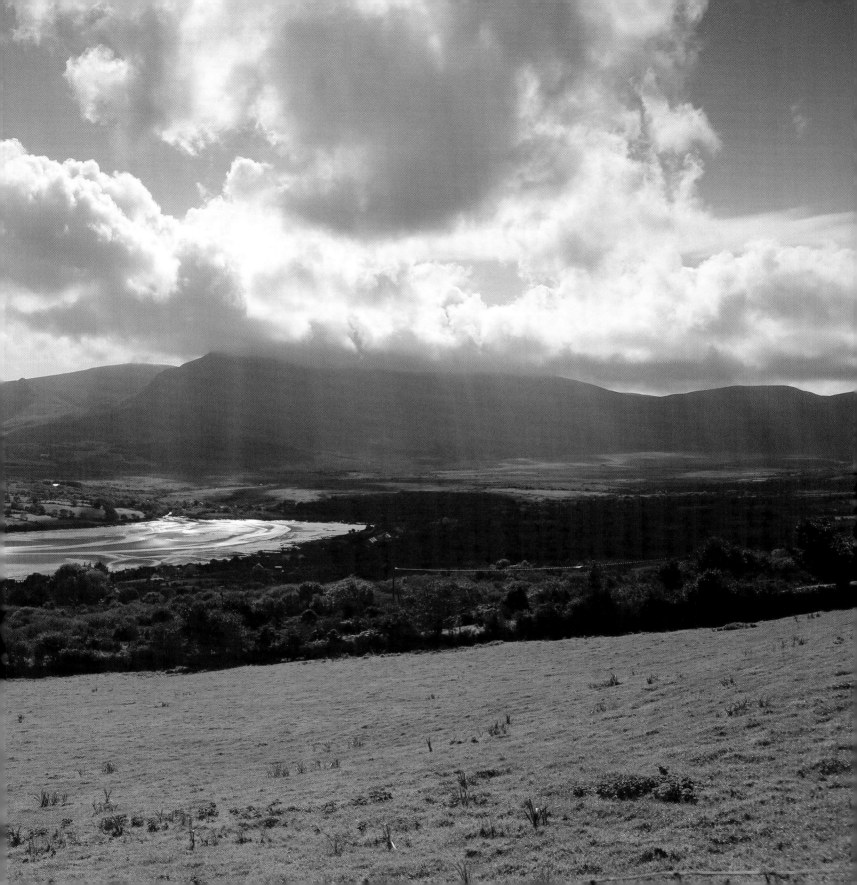

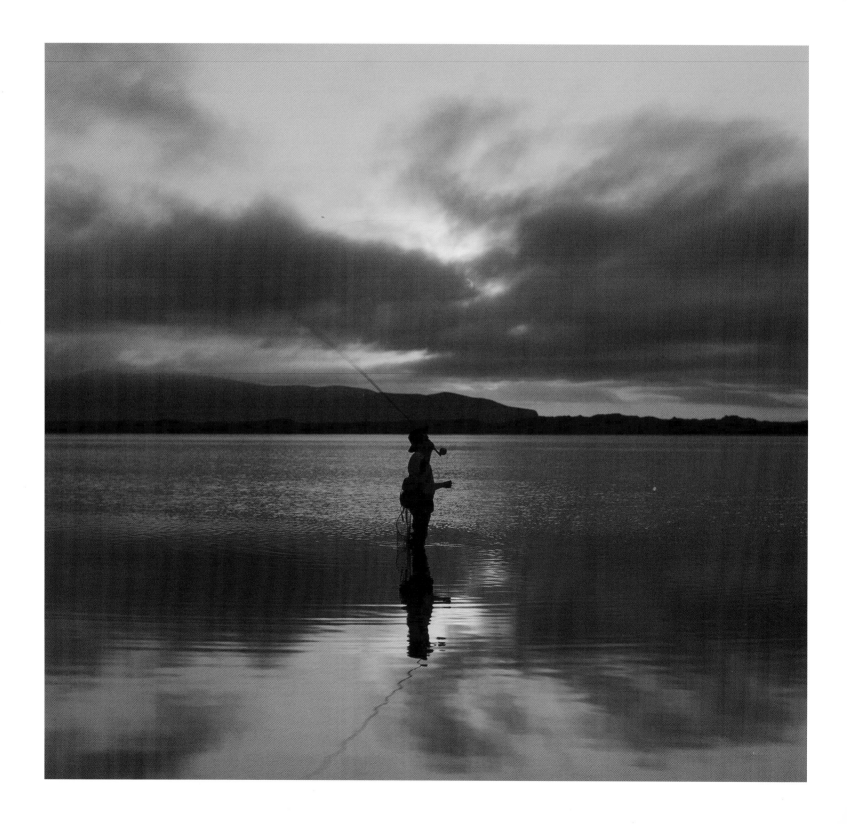

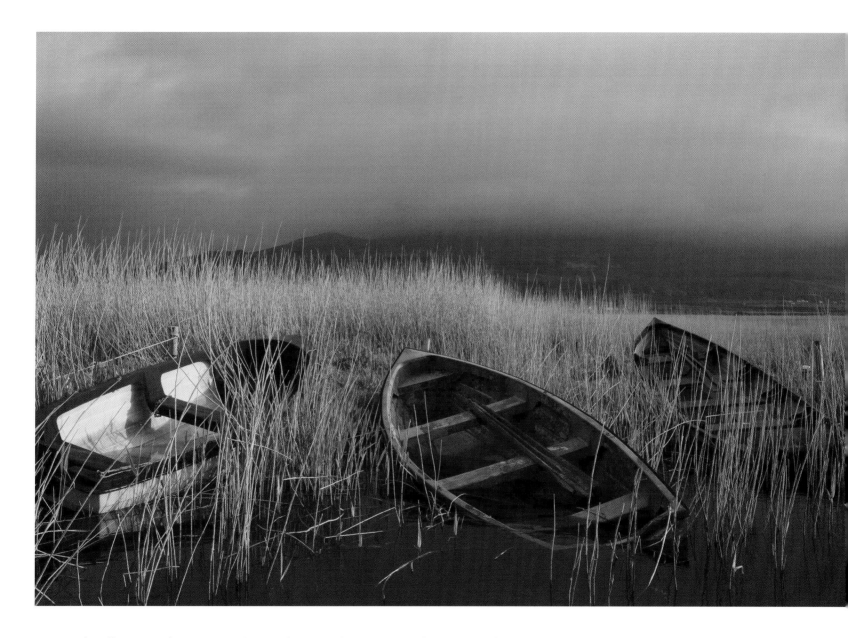

♠ Lough Gill near Castlegregory on the Dingle Peninsula. A fisherman's paradise, it boasts a large colony of wild birds and natterjack toads, which can be heard most summer evenings.

♦ At Lough Gill, near Castlegregory, a fisherman is silhouetted against the evening sky trying his luck with the fly.

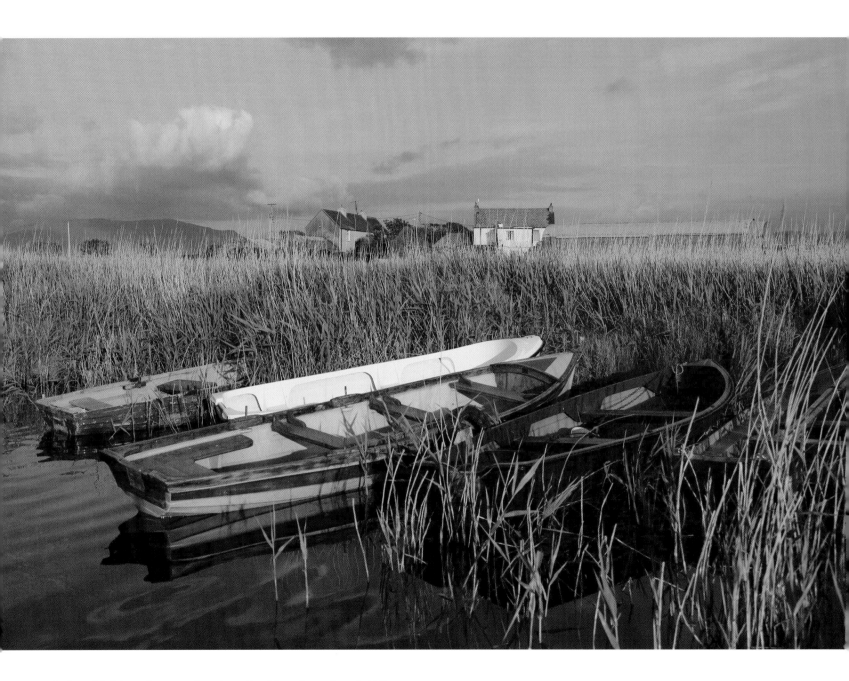

Colourful fishing boats tied to the tall wild reeds on Lough Gill.

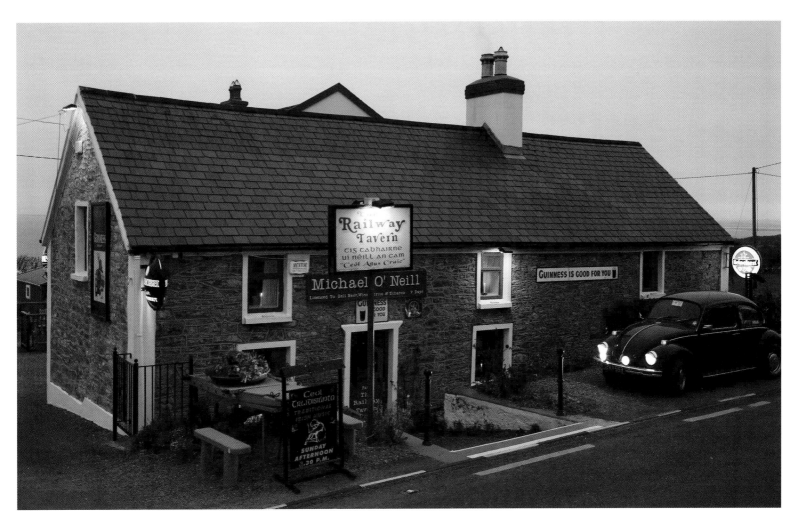

♠ The Railway Tavern at Camp on the Dingle Peninsula.

➤ A pint in the hand of a customer in a Kerry pub.

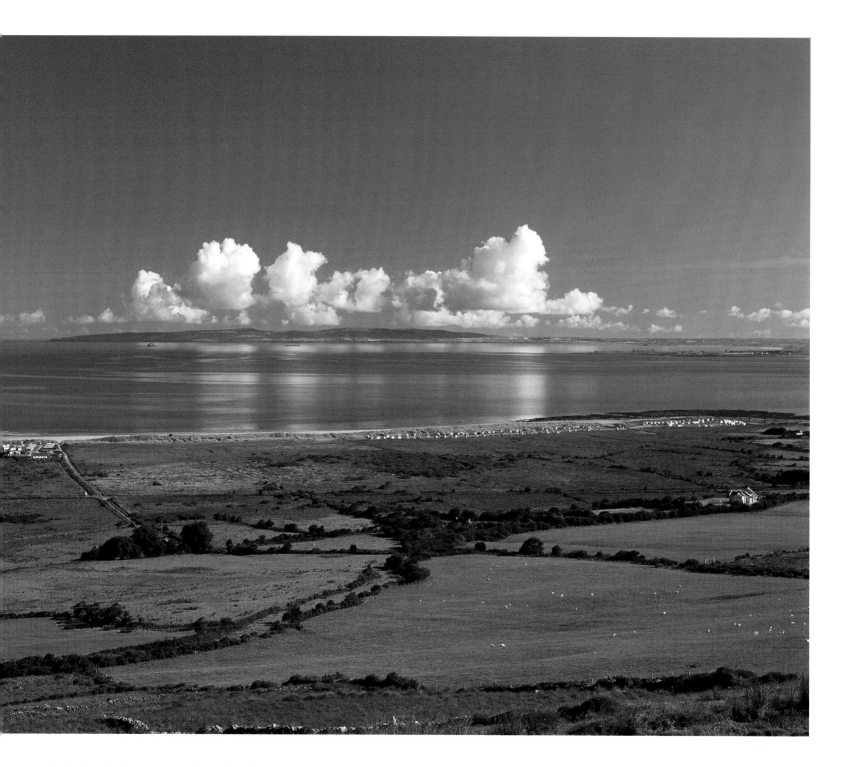

Tralee Bay looking towards Kerry Head across calm Atlantic waters.

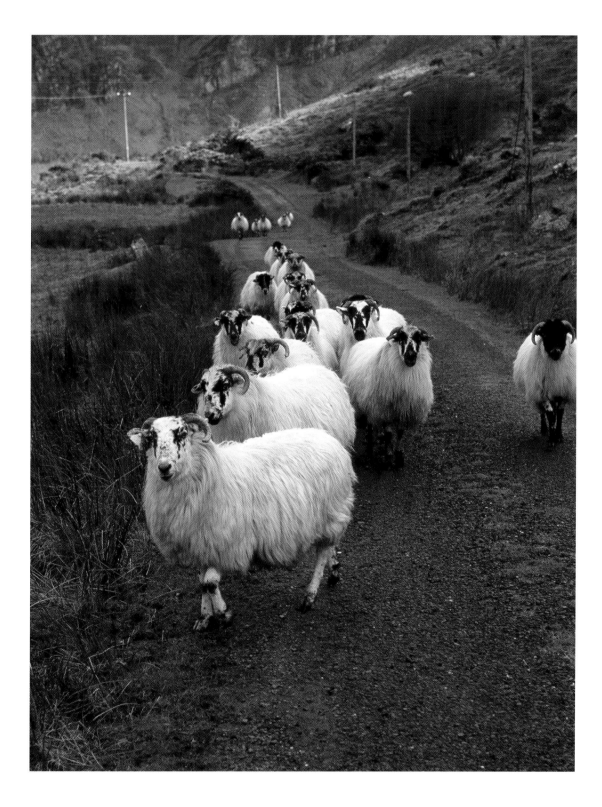

A flock of sheep on a narrow mountain road under the shadow of Caherconree.

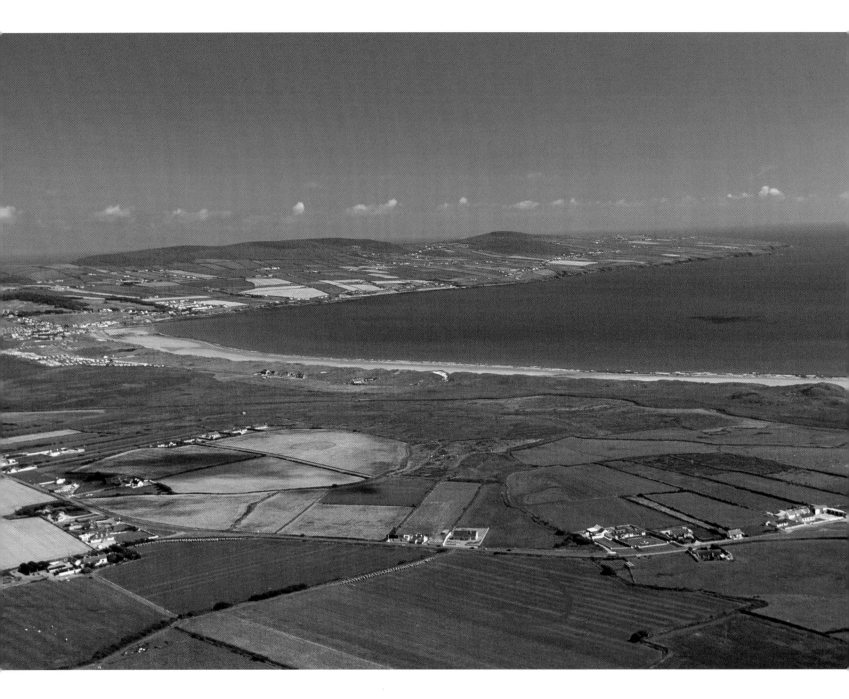

▲ Ballyheigue Bay on the Atlantic, scene of much smuggling in earlier times when ships were lured into the shallow waters of the bay.

➤ A kite surfer at Banna Strand.

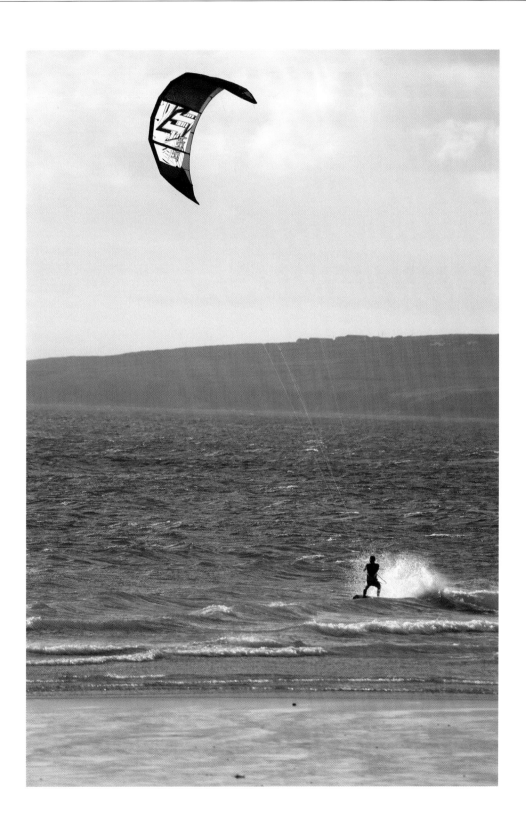

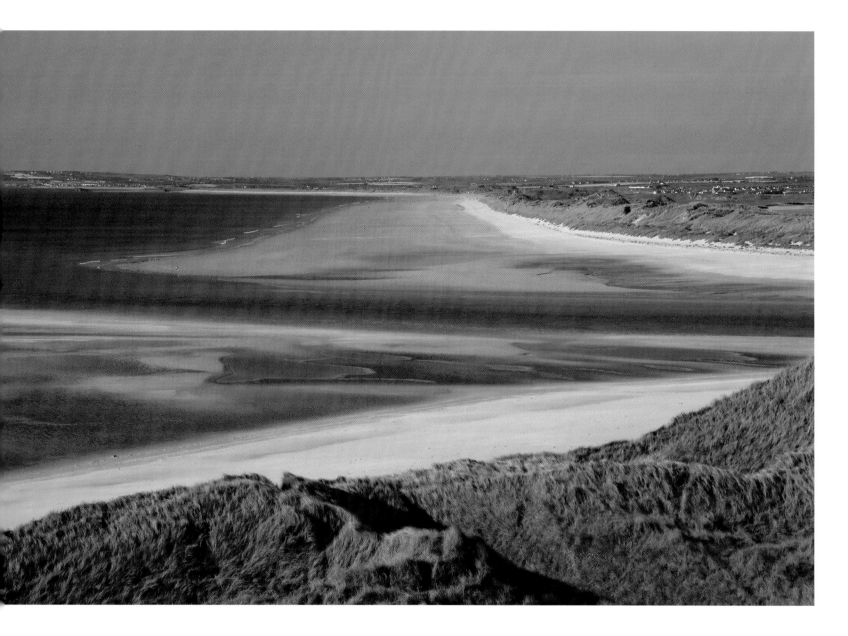

Banna Strand stretches from Barrow to Ballyheigue. It was on this beach that Sir Roger Casement landed on 21 April 1916 in an attempt to bring in armaments for the Easter Rising.

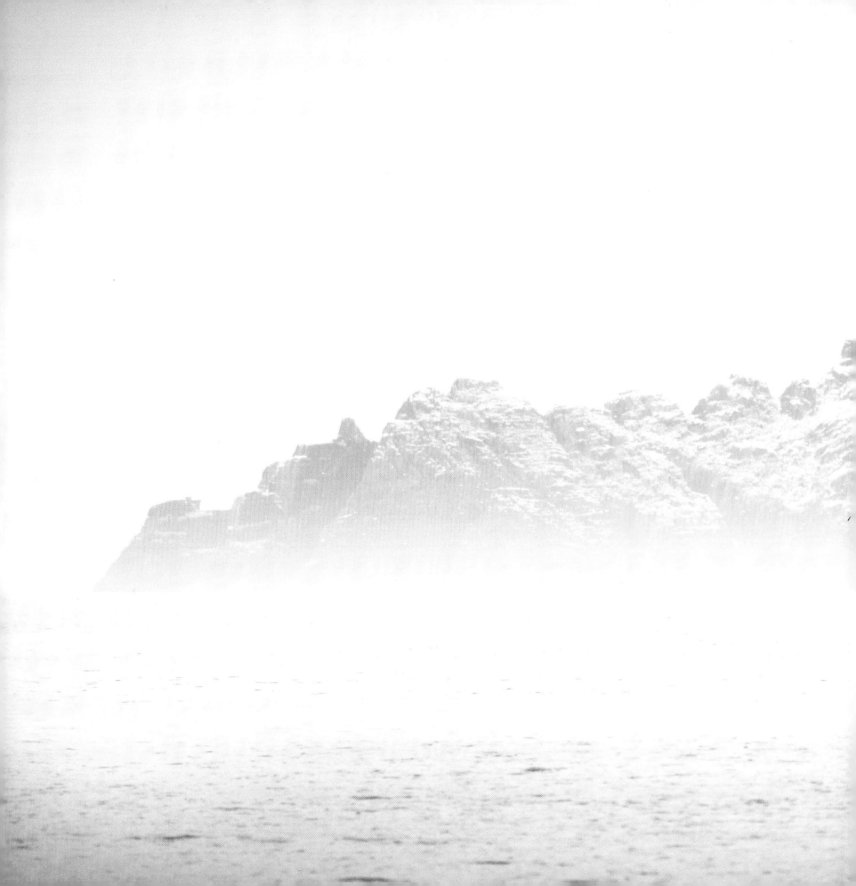